December 24, 2002

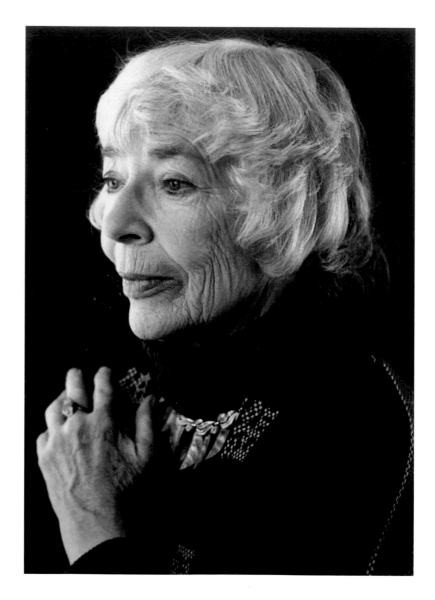

MARY HOLMES

PAINTINGS AND IDEAS

INTRODUCTORY CONTRIBUTIONS
by
Addi Somekh and Gideon Rappaport

INTERVIEWS
by
Addi Somekh

PHOTOGRAPHY
by
Charlie Eckert

Very Press
Los Altos, California

To look at art is to live a thousand times in a thousand places. To collapse the aching stretch of time and space, to expand the nutshell in which we are bounded with our private dreams.

Mary Holmes

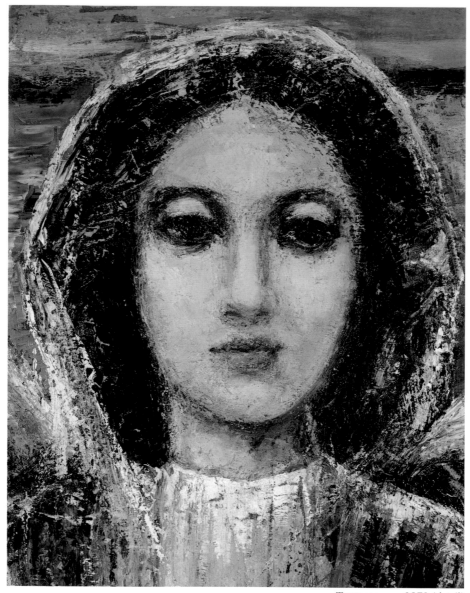

Temperance, c. 1970 (detail)

CONTENTS

FOREWORD

Addi Somekh

A great teacher is, in Plato's metaphor, one who presides like a midwife over the birth of vision in others, who inspires a new and authentic understanding of the world. Anyone who knew Mary Holmes, whether from a single lecture or through years of friendship, would agree that she was such a teacher.

Although Mary preferred to spend her time on her hilltop farm near Santa Cruz, surrounded by animals and producing mythological paintings, perhaps her greatest gift was that of communicating profound and complex ideas in a way that was not just clear but also entertaining. She had a particular sensitivity to the mysteries and paradoxes of life, and she could convey her perceptions in a manner that would make both a preacher and a comic envious. In fact, every time she lectured, listeners would laugh out loud—not because she was trying to get that reaction but because her words became revelations. As she herself observed, when people hear a deep but unexpected truth uttered, they respond with laughter.

"Of course, she's not really an academic," explained her late sister, Sara Holmes Boutelle. "She never has been and never wanted to be one, though she has degrees and honors and all the trappings. But it's something else about her lectures that just captivates people—her magnetism, really, that brings out the best in other people. I've known her all her life, and she's always been that way."

I met Mary Holmes in 1991, when I was nineteen years old and she was eighty-one. I was enrolled at the University of California, Santa Cruz (UCSC), but was beginning to feel that "real" school was not for me. My classes appeared to have more to do with academic theories than with real-life concerns. There was plenty of talking and reading, but it seemed little wisdom was involved. At the same time, my questions about life were growing faster than my ability to answer them, and I was in need of someone who had real insight.

Upon a friend's suggestion, I dropped by the Penny University, the informal seminar group founded by historian Page Smith, which met (and still meets) Monday afternoons at Calvary Episcopal Church in downtown Santa Cruz. It was there that I heard Mary lecture for the first time. I was astonished by her confidence, passion, and class. Her ideas were so profound that I had to grab a pen and write them down so they wouldn't escape my head as quickly as they went in. I returned to the Penny (as it's commonly known) every week. Soon I was learning more in this free conversation group than in all the courses for which I paid tuition or in any of my costly textbooks.

The more sessions I attended, the more I wanted to go up to Mary's farm and ask her follow-up questions about many of the topics discussed at the Penny. But I hesitated. After all, Mary was a genuine scholar and thinker, and I was a teenager with a head full of TV reruns. Fearing embarrassment and feeling painfully ignorant, I didn't visit her.

In 1994 I graduated from UCSC and moved to New York City. There I met a photographer named Charlie Eckert. My part-time job as a balloon-hat maker became a full-time occupation when he and I began traveling the nation and the world, creating balloon hats for people wherever we went and taking photos of them in a kind of rolling investigation of the universal nature of laughter. Ultimately, we visited thirty-five countries and collaborated on a book about our experiences, *The Inflatable Crown*.

By the time we got back to America, I felt that I had learned enough about life to be able to talk coherently about it. I returned to northern California and now began visiting Mary, showing her photos of people Charlie and I had met and relating stories from our life on the road. She was fascinated, especially by seeing the pictures of people's reactions as they received the colorful custom-made balloon hats. It prompted her to talk about the history of headdress—about how all human beings, from primordial times to the present day, have worn symbolic items on their heads. Even though I worked with hats every day, I had never really thought about why people wear them. This led to a ten-hour conversation on the topic (which I tape recorded) that transformed my perspective on my job.

Just as Charlie and I were completing work on *The Inflatable Crown*, Mary asked if we would like to work on a book about her paintings. We immediately agreed. In the winter of 2000, when Mary was ninety, I conducted a series of tape-recorded interviews that in the end ran to some eighty hours. Sitting in her house and in her studio, we discussed topics ranging from the themes of her paintings to subjects she had lectured about as a teacher over the course of nearly six decades. Meanwhile, Charlie turned the painting studio into a photography studio, producing pictures of all her canvases on four-by-five film. The edited transcripts of my conversations with Mary, a selection of Charlie's photographs, and a biographical essay by her former student and longtime friend Gideon Rappaport comprise this book.

Working with Mary was a blessing. For one thing, I finally got to pose those follow-up questions I had long wanted to ask. The answers proved to be both exhilarating and challenging—a true workout. Following a number of our conversations, I was so exhausted from talking and thinking that I would almost be dizzy. By contrast, Mary, despite her various physical frailties, would still be energized and ready to keep going. "I can always keep talking," she would say. "So many endless mysteries in this universe of ours. You can just think and talk about them forever."

■

The interview portion of this book is divided into two sections. The first focuses on the stories and virtues illustrated by Mary's paintings. Her works in the Chapel of the Holy Spirit (which she built on her farmstead in 1993) deal with the nature and variety of the gifts that are essential to living life well. Those contained in the eleven-panel *Throne of Aphrodite: The Saints and Martyrs of Love* illustrate the power of love both to destroy human beings and to redeem them. In this section she also talks about some of the paintings that hang in her studio. The second section focuses on many of the ideas Mary developed and talked about during her teaching career, from the way art affects people to their need to lead meaningful lives.

It is our hope that this book will help keep the beam of Mary's insight shining, illuminating some of the mysteries of this life we all share.

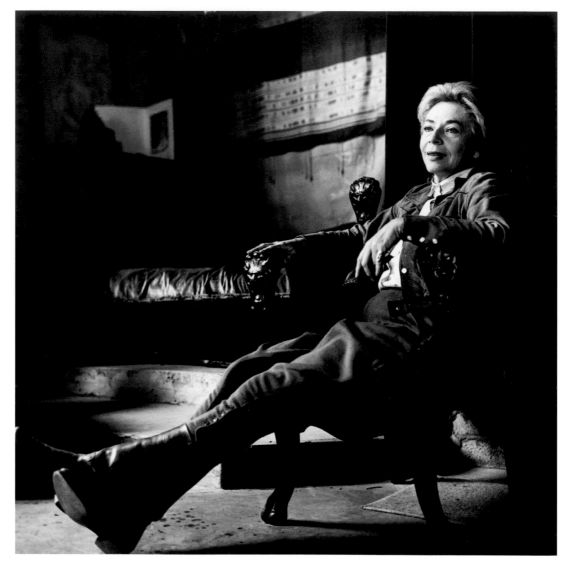

At the castle, Agoura, California, 1961

MARY HOLMES: A BIOGRAPHICAL SKETCH

Gideon Rappaport

Mary Adams Holmes was born in Aberdeen, South Dakota, on May 8, 1910, a date to which she attached at least three kinds of significance: it put her under the sign of Taurus, which seemed to confirm her native strength and independence; she believed it to have been the first Mother's Day; and it yielded her an oracle. In those days, she recalled, it was the custom to assign to a newborn girl the verse from the thirty-first chapter of the Book of Proverbs that corresponded to the day of the month on which she was born. Verse eight reads, "Open thy mouth for the dumb in the cause of all such as are appointed to destruction." Mary always felt this verse to be a calling and an inspiration to speak—for animals, for oddball human beings, and for all who could not articulate the meaning of their own experiences of art and of life.

Mary's father, John Horace Holmes, was born in 1867 to a Quaker family who lived in Mastersville (later Conotton), Ohio. His father was something of a freethinker; family lore has it that he went to a women's rights convention to find a wife. His mother was described in an obituary as a "lady abolitionist and classical scholar." John Holmes was, at various periods in his life, a college president, a banker, a railroad land agent, a mayor, and a farmer. He was a lifelong Republican and active in politics. Mary's mother, Marie Heloise Adams, was born in 1880 to an Episcopalian family who lived near Rehoboth, Maryland, on the Eastern Shore, where her father was a doctor. She went to college and became a schoolteacher. Though to support her husband's political position she once served as president of a Republican women's club, Marie, having been raised a Southern lady, voted as a Southern Democrat (a fact Mary loved to cite as an instance of the significance of the secret ballot). In their later years, both of Mary's parents lived with her. John died at age ninety-nine, Marie at ninety-five. Mary's older sister, Sara, was born in 1909.

All her life Mary remembered a childhood experience that stamped her indelibly. At age four, while standing on the front steps of her grandparents' house on the Eastern Shore, she saw a dead bird lying on the brick walkway in front of her. She made a melodramatic gesture of horror, putting her hands up to her heart. And then she heard a voice saying that the gesture was sentimental and fake. The voice was not hers, was not that of anyone she knew, was not identifiable. Yet it was utterly authoritative. She imagined it to be the voice of God within her and thereafter felt the moment to have been a great gift—the initiation of her lifelong devotion to the authentic in speech and gesture both in her own life and in art.

In 1914 the Holmes family moved from Aberdeen, where Mary's father had worked for the Chicago, Milwaukee, and St. Paul Railroad, to Chicago. There Mary attended one of the nation's first Montessori schools (where she spent four years drawing and painting until the school decided to teach her to read) and then Miss Haire's School for Girls. In 1922 or 1923, when the family moved to Muscleshell,

Montana, Mary was sent to boarding school at the Hannah More Academy near Baltimore. She returned to the family home in Montana for summer vacations.

From childhood, Mary was devoted to painting and drawing. She remembered that people found her pictures to be "impressionistic." Then, when she was given her first pair of glasses to correct her nearsightedness, the world suddenly sprang into focus. Until that time, she said, when people would come into the room she would recognize them more by their shape than by their facial features. Now, the world was filled with clarity and detail. She never forgot the first impression made upon her by the discovery that seeing a tree outside the window could include seeing its particular leaves.

Mary (left) and unidenified fellow student in a play at Hollins College, 1931

After graduating from Hannah More in 1927, she enrolled at Hollins College in Virginia, majoring in philosophy. According to Mary, she regularly made the dean's list—every *other* semester. Being on the list gave a student the privilege of not having to attend classes. Mary took full advantage, spending all her time in the library reading. As a result, her grades would drop and she would be taken off the list. She would then return to classes, get back on the dean's list, re-earn the privilege, and cheerfully resubmerge herself in the library.

In 1931, after receiving her bachelor's degree from Hollins, Mary traveled to Europe with her sister, Sara, and their cousin Frederick Adams, Jr., called "Tubby." Mary spent the year studying in Berlin, Heidelberg, and Paris. While in Europe she drew, painted, visited museums, and attended concerts, to which in those Depression days, she said, tickets cost the equivalent of ten cents.

When she returned to the States in 1932, Mary met a medical artist whose work earned him $10,000 a year, "which was of course a fortune at that time," she said. "I thought, 'I can do that.'" So after a summer in Greeley, Iowa, where her parents had moved from Montana, she enrolled in the medical illustration program at the Johns Hopkins University medical school in Baltimore. Max Brödel, father of modern American medical illustration and founder of the program, "was delighted to have me," she recalled, "because I was a painter and not a scientist." She remembered

With son, Michael, 1937

being assigned to make a charcoal drawing of the anterior superior iliac spine. She finished in a few hours, but when she showed it to Brödel, he sent her back to correct it, instructing her to include "every pore and bump and crease. Six weeks later, it was done. We just kept looking and looking, and it was invaluable." Though Mary quit the two-year program after six months because "it was too bloody and painful," she said, "I wouldn't trade that experience for anything."

In 1933 Mary moved to Madison, Wisconsin, where she and her friend Barbara Betz ran a boardinghouse. When she wasn't cooking for the roomers, who were mostly medical students, she spent her time painting.

In Madison in 1936, Mary met and married Gerald O'Malley. The next year, pregnant, she left Gerald and went to stay with her sister in New York City. There, in October 1937, her son, Michael, was born. When he was about six months old, Mary returned with him to Greeley and eventually was divorced. She never remarried.

Receiving her master's degree from the State University of Iowa, 1941

The next year, with a child to support, Mary taught English at her alma mater, the Hannah More Academy. She then learned that at the State University of Iowa (now the University of Iowa) one could earn an advanced degree just by painting pictures. It turned out that one could also get a degree for writing, and as a talented writer, she was tempted. (All her life she wrote lyrical, often hauntingly moving poetry, which she claimed merely "came to her." And the brief essays she wrote to accompany the Art 5a course she taught at the University of California, Los Angeles, are models of insight and prose style.) In the end, though, she was drawn to the art department, partly because of the presence in it of the painter Philip Guston, whom she found highly engaging, and also, of course, because of her greater passion for art.

Mary received her master's degree from the State University of Iowa in 1941 and stayed on to teach art history there until 1947. While earning the degree, she had served as a teaching assistant to the art history professor Emil Ganso. In that capacity, she had to do hundreds of slide reviews for the students.

> I came to know every slide in the library and what to say about each one and learned to talk on my feet. And then came World War II, which was another marvelous opportunity for me, because all the men left and I taught their classes. Which meant I had to learn things like Near Eastern ceramics and primitive art, things I never would have studied because I was only interested in painting.

By war's end, she was able to lecture on just about any subject in art history.

In 1947 she was hired to teach art history at Ohio State University, Columbus, where she remained until 1953. It was in Columbus that Mary became one of the first people in the nation to teach art on television in a course broadcast on the local station. (She helped to invent the fledgling medium in another way: for the same station, she hosted late-night movies dressed as "Vampira"; her son, then twelve years old, operated the sound boom.)

One evening in 1953, about the time that an Ohio State art professor named Gibson Danes was preparing to head the art department at the University of California, Los Angeles, Emil Ganso told him he ought to invite Mary to teach there. Danes did not particularly like Mary, though his wife did. But that same night,

Teaching art history on television, Los Angeles, c. 1955

Ganso dropped dead. So, responding to his wife's influence and unable to ignore what might have been Ganso's last words, Danes offered Mary a position.

Mary moved to southern California and began teaching at UCLA. At first she lived in Santa Monica. Then, in 1955, she bought a castle on a hilltop in Agoura, which at that time was beyond the farthest northwestern outskirts of Los Angeles. The castle had been built by hand in the 1920s by a Hollywood film writer, an English socialist who believed that everyone in America deserved a castle. Made of cement blocks, it came complete with a turret, a loggia, battlements, and a great hall with a huge fireplace. Mary lived there until she moved to Santa Cruz.

During the mid-1950s Mary had a weekly fifteen-minute television program devoted to art appreciation. It aired on the local CBS station, KNXT (Channel 2), and was popular, making her something of a celebrity in Los Angeles. Observing her lecturing at KNXT one day, the writer-director-producer Joseph L. Mankiewicz said to Mary's hairdresser at the station, "That woman has star quality. But don't tell her!" The hairdresser told her anyway.

Not all members of the UCLA art department approved of Mary's star quality. Her lack of a doctorate and scholarly publications, combined with her popularity with students and the TV audience, offended their sense of academic decorum. In 1956, when Gibson Danes left UCLA for Yale, Mary lost her job. To earn money she

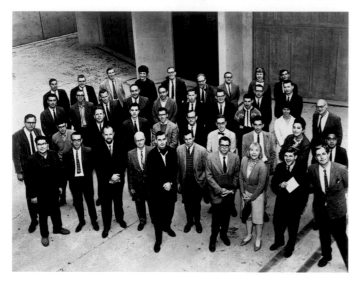

First-year faculty of Cowell College, 1965 (Mary is third from right in front row)

painted portraits of her friends, including the actresses Angie Dickinson, Mildred Dunnock, Susan French, and Julie Newmar. She also gave talks to an informal women's group in Pasadena. (The group continued to invite her to speak even after she moved to Santa Cruz.) In 1958 Lester Longman, a friend of hers from the University of Iowa, became head of the UCLA art department and hired her back. Again her popularity among students was high; her departure for Santa Cruz in 1965 made the headlines in the UCLA *Daily Bruin*. (Also, as Mary often laughingly recounted, it prompted members of the art department to pass a motion that she should never again be permitted to teach at UCLA.)

While at UCLA, Mary became close friends with the American historian Page Smith, with whom she enjoyed discussing how to make an ideal university. In the early 1960s Smith was asked to become founding provost of Cowell College, the first of the residential undergraduate colleges at the new, experimental campus of the University of California scheduled to open in Santa Cruz in 1965. He set the tone for UCSC by declaring his intent to hire a faculty more devoted to teaching than to research. "[She] was my first appointment," Smith later said. "I knew Mary was the most marvelous lecturer, and if I could get her to come up here, we'd have a wonderful World Civilization course—and we did."

In that two-year core course, Mary lectured to the freshmen on Western art from ancient times to the twentieth century. To the sophomores she lectured on American

With students, c. 1955

art and on the art of Islam, India, China, and Japan. She also taught individual classes on the art of ancient Greece and Rome, medieval Europe, the Italian Renaissance, the northern European Renaissance, the seventeenth century, Romanticism, the nineteenth and twentieth centuries, China and Japan, and India.

To those who heard her once and those who heard her time and again, Mary's lectures provided fresh and vibrant insights into the experience of life and art. She could also get listeners laughing uproariously, though she never thought that was because she was particularly witty. "People laugh when they hear the truth spoken," she said, "because people simply delight in the truth."

Laughter was not the only response to Mary's gift for vividly articulating what we know to be true as soon as we hear it expressed. Once, early in her career, she was invited to speak about the art of India at Wilson College, a small women's school in Chambersburg, Pennsylvania. Mary prepared by going to the slide library in a rush the day before her trip and grabbing all the relevant slides she could, planning to arrange them and her thoughts the night before the lecture. She arrived at the college in the afternoon and was greeted by the head of the philosophy department. ("A mad expert on India—his library was a room lined with nothing

but books about India.") He immediately spirited her off to a cocktail party and then to a formal dinner. There she found to her dismay that she was to be the keynote speaker for a weeklong cultural event devoted to the philosophy head's pet subject. The audience would include not only the expected college girls but also India's minister of culture, who had specialized in Indian art at Oxford, plus a delegation of Indian embassy officials.

That night, intending to arrange her slides in bed after a warm bath, Mary fell asleep. She awoke amid a jumble of slides to a knock on the door summoning her to a "typical Indian breakfast," after which she was to give the lecture. She rose, dressed in a hurry, and rushed to the breakfast. When it was over, she handed the bundle of mixed slides to the projectionist and began to speak. She talked for something over an hour to a politely listening audience. When she finished, there was not even polite applause—only an utter and seemingly interminable silence. Mary was feeling that the best she could hope for was to beat a hasty and embarrassed retreat. Then the audience erupted into loud applause, cheers, and a standing ovation. The minister of culture came onto the stage and said, with tears in his eyes, "Miss Holmes, you have shown us ourselves as not even one of us could have done." He then bowed, kissed her hand, and invited her to visit India as his guest. (She never took him up on the offer.)

At Cowell College, 1970

In addition to her teaching, Mary's presence added luminosity, color, and drama to life at UCSC. In a human chess game, she played the white queen in an elaborate homemade costume. At other events she dressed as a gypsy and told fortunes with tarot cards, rode horseback in a ceremonial procession, was the Nurse in a group reading of *Romeo and Juliet* and Titania in *A Midsummer Night's Dream*, and played Miss Prism in a university production of Oscar Wilde's *The Importance of Being Earnest*. (Responding to praise for the authenticity of her performance, she claimed to have done nothing but imitate the gestures of her mother, who had been well trained in nineteenth-century Southern etiquette.)

She painted the college's formal portrait of Provost Page Smith on his retirement in 1970, and the Junior Common Room (sometimes called the Fireside Lounge) at Cowell College is home to her seven-panel mural, *The Return of Aquarius*, completed in 1974.

Mary taught at UCSC until her official retirement in 1975 and thereafter, as professor emerita, continued to give a variety of courses and free public lectures at the university for two decades. Among the titles of her lectures and lecture series: "Why Art?" "Can Anybody Love Art?" "Art and the Inner Life," "Can Art Be Underground Now?" "The Universality of Art," and "The End of Art."

She was also a regular leader of discussions at the Penny University in Santa Cruz, which Page Smith founded in 1972. In the beginning, the Penny University, named after the English coffeehouse gatherings of the eighteenth century, offered five individual classes that met weekly in a downtown coffee shop, each class led by a different teacher on a different day of the week.

In 1973, when Visiting Professor of History Donald Nicholl left UCSC to return to England, Mary took over his slot at the Penny (as locals call it), and the number of those attending on her day grew. After some months, Smith and Mary decided to join forces, condensing the Penny into an informal weekly seminar led by the two of them. In later years Paul Lee, formerly a professor of philosophy at UCSC, and James Bierman, a professor in the UCSC theater department, joined as co-leaders and

continued with Mary after Smith died in 1995. In this form, with a change of venue to the social hall of Calvary Episcopal Church in Santa Cruz, the Penny has continued to meet every Monday at 5 P.M. for almost thirty years. Free and open to all, it is an ongoing conversation that wanders through topics ranging from local, national, and international politics to the arts to technology to ecology to the distant past and the distant future to the meaning of life.

Mary was interested in people of all ages, backgrounds, and aptitudes. At a lunch or dinner at her house one was as likely to meet a German countess, a drug-dazed

In her painting studio, 1973

hippie, a Hollywood agent, a wealthy cattle rancher, a royal calligrapher, or a renowned psychotherapist as an academic colleague. One was equally likely to encounter people who had just met Mary and others who had known her for decades.

Always, there were animals around: dogs and cats in the house, and, in the barnyard, chickens, guinea fowl, geese, peacocks, goats, sheep, a cow, and, most especially, horses. Mary loved horses and horseback riding from the time she was a child. Once asked how many horses she owned, she answered, "That's like asking an alcoholic how many drinks he's had: I'd only lie to you." For many city-bred visitors, including her three granddaughters, Mary's place provided rare firsthand experience of country life around animals.

And everywhere, inside and out, were works of art: every kind (paintings, drawings, sculptures, furniture, tools, curiosities, junk, artifacts without category), every quality (good, bad, figurative, abstract, fine, popular, original, reproduced, sophisticated, naïve, profound, sentimental, crass), every medium (wood, feathers, marble, crayon, clay, plastic, watercolor, cloth, paper, stone, cardboard, brass, papier-mâché, iron, rusty iron, and porcelain, not to mention oil on canvas)—all testifying to Mary's passion for seeing the imagination at work in the things human beings make.

From 1968 until the end of her life, Mary lived with her menagerie of animals and art on a sixty-acre farm about five miles north of Santa Cruz. It is known, in

At a party in Santa Cruz, c. 1987

part, for its unpaved, bumpy one-lane driveway, which climbs perilously through seven hairpin switchbacks up a steep, wooded slope to the cleared hilltop. There one sees first the vineyard planted by Bruce Cantz, Mary's beloved friend and helper for more than thirty years, who owns and operates the Four Gates kosher winery. Beyond the vineyard are Mary's house, barn, and studio. And beyond them are several structures, built in the 1990s to Mary's specifications by local carpenter (and one-time tenant on the farm) Larry Makjavich. These include the cinder-block Chapel of the Holy Spirit (built in 1993 with two side chapels to house three sets of Mary's paintings on the subjects of the Gifts of the Holy Spirit, the Virgin Mary, and Holy Wisdom); a large cement labyrinth laid out on the ground beside the studio (illustrated with Mary's drawings of the Seven Days of Creation, scratched into the wet cement with a nail duct-taped to the end of a cane); a seemingly rustic shack sheltering the sculpture *The Mother of Us All*; a semicircular, columned shrine with a seashell motif containing the paintings comprising *The Throne of Aphrodite: The Saints and Martyrs of Love*; and the barn-studio, which contains Mary's library and many of her paintings and drawings.

Despite the challenging driveway, Mary always had many visitors—friends, former students, colleagues, and acquaintances as well as people who had simply heard about her and came to meet her. While most people see the number of their friends decline as they advance into old age, Mary, toward the end of her life, had as many friends as ever and never ceased making new ones.

■

From her late fifties on, Mary suffered from severe rheumatoid arthritis and, later, from chronic leukemia and related diseases. Throughout years of pain, life-threatening infections, and increasing physical debility, Mary remained cheerful, continuing to ride horses into her eighties and to paint and draw into her nineties. She refused to give physical suffering more than a minimal place in her consciousness. Her gifts of insight, good humor, and pointed speech accompanied her until the end.

During her last week of life, Mary heard parts of this book read to her, delighted to see its reproductions of her paintings, and was eager to know her visitors' opinions of it. She died peacefully, early on the evening of January 21, 2002, at age ninety-one. Her ashes rest in the Chapel of the Holy Spirit.

As the white queen in a human chess game, Cowell College, 1968

PAINTINGS

CHAPEL OF THE HOLY SPIRIT

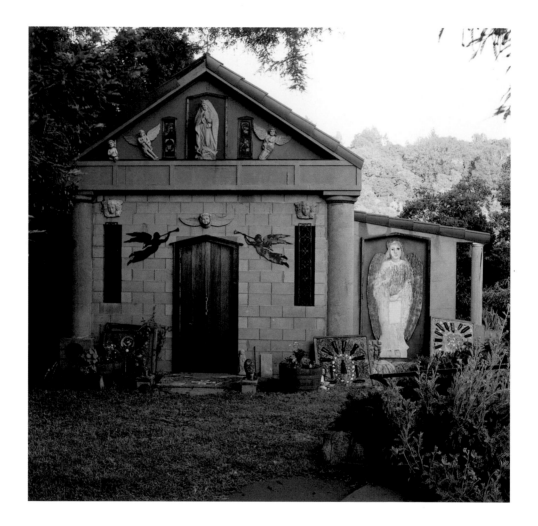

Chapel of the Holy Spirit, 1993 (west facade)

Building the Chapel

FAITH

HOPE

SELF-DISCIPLINE

TEMPERANCE

AGAPE

EROS

HOLY POVERTY

GENTLENESS

JOY

Gifts of the Holy Spirit

Building the Chapel

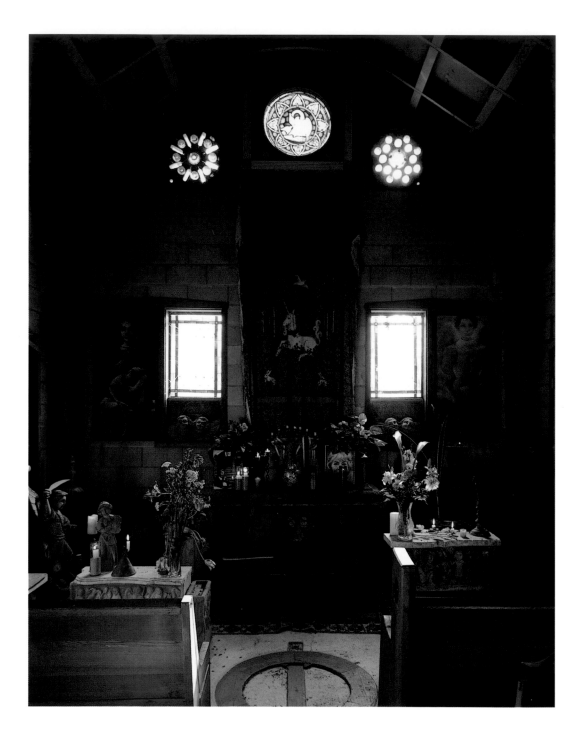

East wall and altar

How long had you wanted to build a chapel?

Oh, a long time. I had thought about it and planned and hoped to be able to build one, and so finally I decided I would. The man who works for me, Larry Makjavich, had just built me a dairy, and he made it out of cinder blocks. It's actually a fortress: it's a dairy that will challenge all the efforts of time to destroy it because it is mighty solid.

But with the success of that, I decided that he could build me a chapel. It was a very good decision because it allowed me to make a place for my paintings. Anything I paint, really, is concerned with qualities of the spirit, or has something to do with the mysterious thing that we all are as spiritual beings.

So it was nice to have a place that my pictures are at home in. I had a great deal of pleasure in making the chapel and bringing it all together.

How did you decide the shape of the chapel?

Well, a lot of canvases are sixteen by twenty inches. So I just expanded it to sixteen feet by twenty feet instead. And I think it is an agreeable shape. It's close enough to feel that it is an intimate place, yet it also has enough room to function as it does, as a public chapel.

It's really not expensive to put up a building this size when you build out of cinder blocks. I sometimes say it is cheaper to build a chapel than to frame all these pictures, which is true because the pictures are large and framing is expensive. So I'm just delighted by it.

Once the chapel was built, how did you select which paintings would go inside?

The chapel is dedicated to the Holy Spirit. And all the paintings in it are the gifts the Holy Spirit can give us, if we can receive them. The gifts are Faith, Hope, Self-Discipline, Temperance, Agape, Eros, Holy Poverty, Gentleness, and Joy.

The Holy Spirit offers us these gifts, and you are given them if you will take them. It's just like a gift, you see. You can't buy it, and you can't bargain for it. It's no longer a gift if you do those things.

What is the Holy Spirit?

It is an aspect of God that operates right in our world. It is whatever runs the universe as it can speak to us individually. It has no physical manifestations, so it can't be depicted. But it is symbolized by different things. And the only way to encounter the Holy Spirit is to be open to it. It is not at all under your control. It's not a thing you can command. People simply become possessed by the spirit.

So the paintings in the chapel are my interpretation of people's relationship to the divine.

CHAPEL INTERIOR

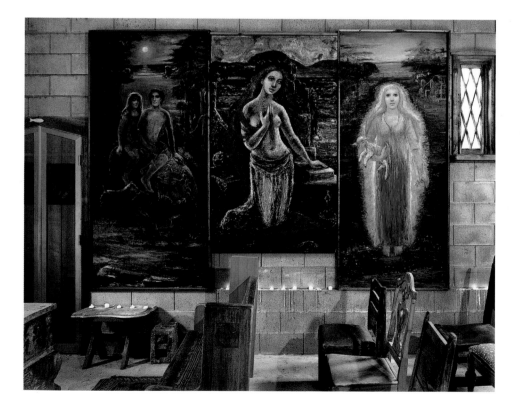

South wall

West wall

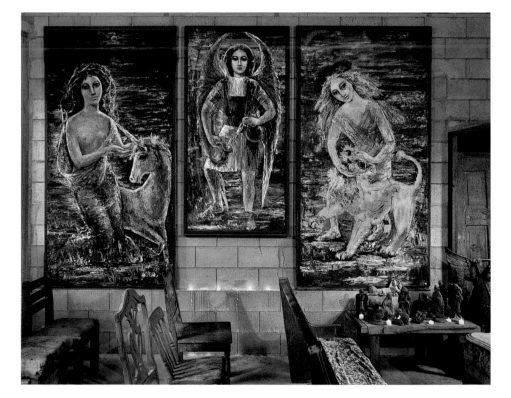

North wall

FAITH

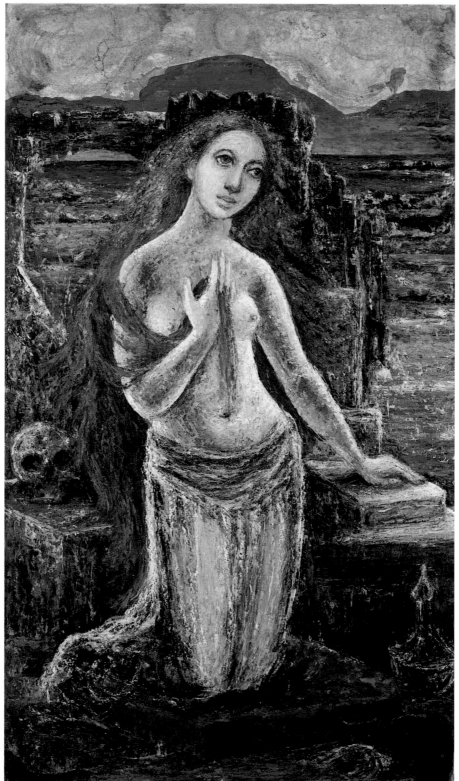

c. 1965
Oil on Masonite
46 x 80 in.

How is faith one of the nine gifts?

You have to have faith to do anything. You have to have the faith that it is worth doing it, for one thing. Because for us as human beings, seeing is believing. That is, a thing only becomes real when we see it with our own eyes. But we cannot see into the future. So faith is the only way that we can accept the fact that we don't know the future but are still able to imagine it and act on it.

If you can't find that faith, you can't do anything. You are paralyzed, as if you were literally paralyzed.

Most people think about faith in the religious sense, as belief in an unknowable God. But from what you're saying, even an atheist scientist concerned only with facts and evidence operates under faith.

Yes. Science is based on one of our great faiths in the present time, that something can be profitably examined from the point of view of knowledge and that we will clear up mystery. We think of mystery as something that will be solved, if not next week then next year, or in another ten years, but eventually we'll understand it.

Science is also based on the faith that once the mystery is solved, human beings in the future will use the knowledge wisely.

Yes, that is right.

So every time we get into an elevator, we are acting on the faith that the owners have kept it safe. Whatever we do, we must have faith that it won't hurt us.

The same thing is true with love. Love without faith in the person is simply barren. Unfortunately, the relationship can progress, but it is constantly tormented—by jealousy, the endless probing and fear. You are always questioning. You are sure the worst is going to happen. So then love without faith becomes a curse instead of a blessing.

Who is the woman in the painting Faith?

She is Mary Magdalen. And the reason that I use her for this figure is that she was converted to Christianity by seeing the head of Christ. She was a genuine party girl, with all that suggests, a high-class prostitute. But it was a dignified and very enviable position because she lived in the most luxurious, high-society way. Five or six people were coming out of a party, went on a kind of parade—a group of people with musicians following them—a celebratory experience. And as they were going down this narrow street, Mary Magdalen looked through a window and saw the head of Christ. He was talking to a group of people at a dinner, and when she saw his head she was instantly converted. Thus she is an example of faith. Of such faith—it doesn't take proof, it doesn't take any argument, anybody else's help or experience. She just saw and believed.

And she is kneeling between a skull and a book, on which her left hand rests.

The book is wisdom, all aspects of wisdom. The skull represents the contemplation of death and how short life is. We always live in the presence of death, which has ultimate dominion over our physical selves. She is represented with them because she devoted the rest of her life to ascetic practices in adoration of Jesus and to prayer.

There is a saying, "Faith without work is dead."

That is true, and I tell you, it's such an important distinction. It can't be emphasized enough. An important part of faith is how you act on it. And it is so easy to sit back and say, "Oh, I have faith that everything will come out all right." Well, you know, you don't have any right to that faith unless you're working to have it be true. It won't happen unless people are active.

So how do people's lives benefit if they have faith?

They are much better off. Actually physically much better off. When people go into despair, their bodies go into despair, too.

And I think people who have faith experience life more fully. They are not limited to just the facts. They are aware of the facts but also are aware of something larger. Faith illuminates life and gives a whole extra dimension to what is going on.

HOPE

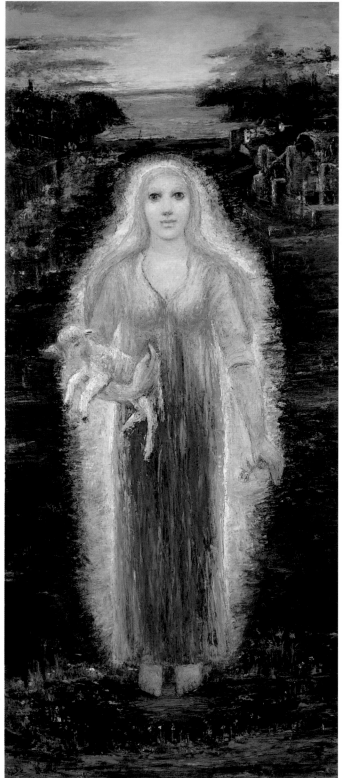

1993
Oil on Masonite
40 x 94 in.

Hope *is a beautiful painting. The woman is young, calm, and literally radiant.*

What she holds are a lamb and a flower. The lamb is innocence, and the flower is rebirth. What I intended by that is that all young things offer us hope. All human beings, no matter how depressed and gloomy—when we see a young thing, a young dog or young child, a young anything, we are flooded with the idea of the immense possibility that is open to them. Just life itself. And that feeling is full of hope. And all nature offers us hope, just by its beauty and persistence.

There is chaos and destruction in the city behind her, but she is healthy and glowing.

That is because hope is an active healer. You read in medical literature that if people give up hope, there is nothing you can do for them. They certainly won't recover from a serious illness.

What is the difference between hope and faith?

They are very closely linked, but they are different. Faith, you can say, gives you hope. But hope doesn't give you faith. So that is an important distinction. Hope is the conviction that nothing is set, that nothing is inescapable. And therefore, it is full of optimism. It refuses to accept that what is going on now will keep on going forever the same way and that there will be no escape from it. But it believes the opposite, that things can change overnight.

I think that hope is very difficult for people to hold on to at the present time. Much more than when I was a young girl. In the 1930s in America all kinds of people had all kinds of hope. It was the time of the wildest flowering of weird ideas that were going to solve the problems of the world. There was a feeling that the world could be made perfect, that you could make a big difference. Among the very well-educated people you knew, few would confess to being anything but a socialist or a communist. Everybody who taught me and my colleagues was a pacifist. And of course, this was right before one of the most extraordinary wars.

Why have people lost hope?

I think it's the extravagance of their hopes.

When I was in Germany, in 1931 and 1932, it was in a state of complete despair. I was horrified by the number of beggars on the streets in Berlin. There were two or four to a block. They were crippled from the war or had been gassed or were destroyed completely in the mind. It was terrible, as only a big city could be.

And Hitler gave people great hope. Which is the kindest thing you can do, except the hope was a false hope, and that becomes the cruelest thing you can do.

So how do people tell the difference between true and false hope?

It is a very, very difficult thing to tell at the time, and that is what happened in Germany.

Any social healing has to begin with hope, with some people having hope that it can even be done. So where does hope come from?

Hope is tied to the conviction that things change. Despair is tied to the conviction that nothing changes. But the fact is that life is going to change, no matter whether you say it's going to change or not—it is going to change.

Still, you can't explain why some people are hopeful and some are always seeing the gloomy side and always anticipating something bad. And the worst thing that can happen to a human being is to lose hope. All of life becomes gray and meaningless. It's a terrible torment. Yet you can't command hope. You can't say, "Well, I'll be hopeful today."

So if we can't command or create hope, it must come to us somehow.

That's why it is a gift of the Holy Spirit. But people can invite hope by being ready for it, by being able to accept it. It is a feeling that says, "I'm going to believe in it," literally. It points to something beyond itself and says that things are valuable and that what looks like waste is not waste. As my friend Theresa said of the young lady in this painting, "She has gathered the fires of destruction to make light."

SELF-DISCIPLINE

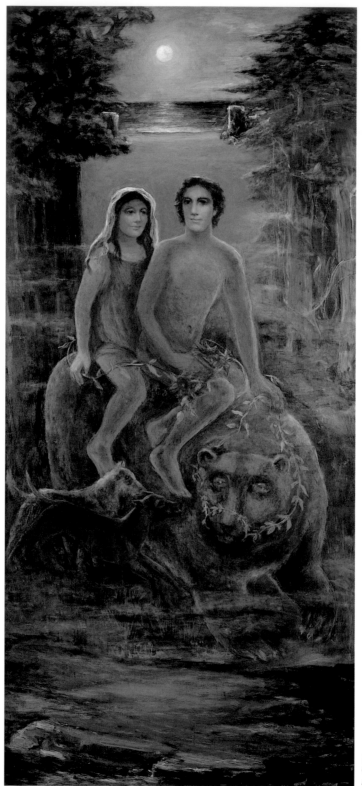

1993
Oil on Masonite
44 x 94 in.

I don't think there is a person alive who doesn't have a problem with self-discipline. So how is it a gift of the Holy Spirit if it is such a difficult and elusive virtue?

As I get older, I have more and more belief that people are born with everything inside of them, their whole personality and potential, and what they do with it is their particular test in life. And that's where self-discipline comes. It is the whole awareness and consciousness of the self.

Because you can't have self-discipline without being aware of yourself?

Exactly.

And yet some people live their whole lives and are never aware or disciplined.

Yes, that's right. And some people never find their particular thing. They just go about spewing energy in all directions without its working for them. Most people waste whatever they're given. Because it's part of themselves, so they don't value it in the same way. They don't think that it is something that could be developed.

So you could be born with a great amount of potential, but without the self-discipline . . .

Nothing comes of it. It is wasted genius.

The painting of the gift of self-discipline shows a man and a woman riding on a bear.

The man and woman symbolize everybody—the two sides of being human. And the bear is a symbol of strong physical, animal nature. Our bodies are like animals. They have the same development, the same period of prime time and decay. They are our vehicles, actually. They are what carries us around and keeps us in contact with this world because our bodies are part of this world, and they go through the same process that every living thing in this world goes through.

The man and woman use a garland to harness and control the bear. The yapping dogs are the funny, trivial, silly aspects of the animal/vehicle body, the things our bodies do as if by themselves, to our disgust or frustration, like nail-biting.

What does the harness of flowers mean?

It's a combination of gentleness and strength. In a sense, there is no such thing as self-discipline. It's really that you are disciplined by what you desire, what you love. The vine is a passion-flower vine, and that drives the bear, not force. But you have to know how to use it with your hands.

The flowers symbolize the ease, the beauty, and the delicacy that any treatment of the body deserves, not whips and spurs. I'm against the harsh discipline of the body that some people practice. It is the refusal to recognize that our bodies are ourselves. To repudiate the body and to torture it and have contempt for it is a terrible, terrible thing.

There have been many groups throughout history that have believed in that type of harsh discipline. I'm thinking of the flagellants in Spain who whip their own backs to show their devotion to God.

And most people who have practiced ascetic discipline know at the end of their lives that it was foolish. In some parts of Buddhism, the ascetic discipline is amazing. People take a vow that they will never lower their right hand, and they don't— just to show absolute control over the body. But Buddha's enlightenment consisted in not having any ascetic emphasis to life. The idea was to live it as decently as you can and not torture yourself with different forms of punishment of the body, fasting, and so on.

So, there is a distinct difference between the self-discipline that is forced and harsh and one that is holistic and healthy.

It's a very different thing if you do something out of love or if you do something because of shame or guilt or obligation. Through the discipline you still achieve a level of transcendence. But you are motivated and compelled and literally changed through the love and respect for what you are doing. I think that is the happiest thing that can happen to a human being.

TEMPERANCE

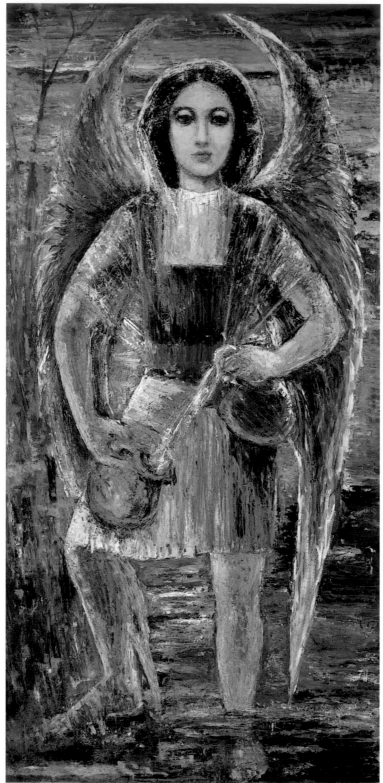

c. 1970
Oil on Masonite
38 x 76 in.

*W*hen you have lectured about the paintings in the chapel, you've mainly focused on the individual virtue each painting represents, and talk about them in individual ways. But when you talk about the three virtues of Temperance, Agape, and Eros you seem to link them. Why is that?

The reason is that everything that we experience in life should be tempered and have a balance of nature. So the Angel of Temperance is the center figure. She stands with one foot in the water and one foot on the land and pours from one pitcher into another. It is an aim to balance.

On the sides are Eros and Agape, the two great aspects of love: the erotic and altruistic. Eros is everything that we think of as physical passion. Its emphasis is on the body. And Agape is a universal, unconditional love. Its emphasis is on the mind and soul.

Both Eros and Agape see love as necessary for living, because love is the basis of our lives. The two are also very different and should be treated in different ways.

The woman with the lion [Eros] also symbolizes strength and courage and power or force. And the virgin with the unicorn [Agape] symbolizes self-sacrifice. And they also need Temperance between them.

Temperance is not easy to attain because we learn from experience. And so our development is based on trying new things, making mistakes, and then making adjustments.

Yes, that's true. We are not tempered by nature. By nature we are much more likely to be passionate and irrational, and almost always we have one or two characteristics that are dominant, with others less developed. So every system of belief or of understanding has always tried to help us over these things that we get stuck on. We have been given many guidelines that we can follow in the world, and most of them are reduced to something that is very similar wherever it appears. And it is the idea of temperance or the balance of life that repudiates the excess that people have been tempted by. All the

great philosophers and teachers of every kind have always advocated temperance. Even in temperance itself, you have to be tempered.

What, then, is the difference between temperance and self-discipline?

They are different but related. Temperance requires a certain amount of self-discipline. Because people need to discipline themselves in order to change certain things to achieve balance. But with such a thing as self-discipline, people can get so involved with the actual event that they have no balance in what they do. Self-discipline taken to an extreme can become unhealthy or even dangerous.

You see, the greatest virtues become the greatest evils if they are done too hard or done unrelentingly. And then the thing that was the virtue destroys the person's life because it turns into something unnatural.

To the left of Temperance *is the painting* Agape.

Yes. *Agape* is a Greek word. It means fellowship but doesn't have any proper English translation. The Hellenic people spent a lot of time analyzing the nature of love. And they divided it. They tried to make clear that there were different aspects or stages of love. Friendship was one. Erotic love was another. Family relations were still another. So you could tell the difference and never confuse erotic love with the love of your parents, never confuse friendship with love for your parents. They are different loves. It was the same kind of mental activity—to analyze and stratify love in everybody's life—as our desire to understand what is the ultimate material of the universe.

Then agape became the great thing of the early Christians because they introduced the extraordinary idea that we should love each other. I don't know of any other society that ever thought this. It's a perfectly extraordinary instruction that Jesus made, that we should love our enemies.

What agape allows is a love that is not part of your ego, is not a part of your self. It is something larger than that, and furthermore it's undeniable and

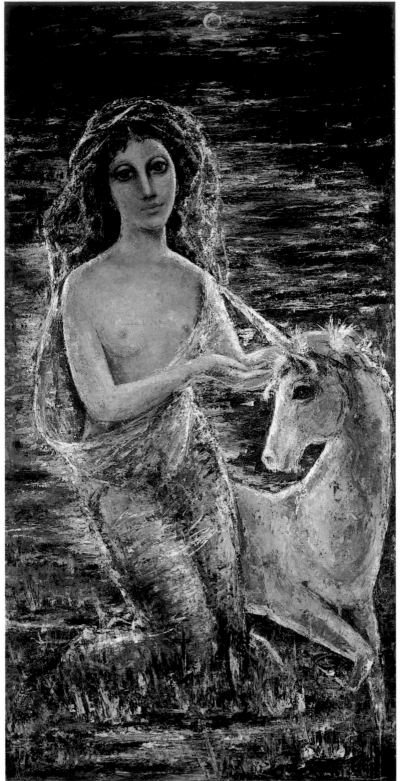

c. 1960
Oil on Masonite
48 x 96 in.

unconditional. It's love of the natural world, love of God. It's the kind of love people feel for the whole universe and for everything in it.

Is agape like compassion?

Yes, it is. But it's more than that. Compassion has a sense of "I'm here and you're there and my feeling is compassionate toward you." You empathize, and you care. It's a type of love that you feel for something that isn't yourself. Agape recognizes that we are all in the same boat, without any idea of how we got here, without any idea of what is going to become of us.

Compassion is much easier than love, because love isn't controlled easily.

To represent agape you have painted a unicorn and a virgin. Why?

There were a lot of different stories about unicorns. It is wonderful that what we tend to think of as a purely imaginary animal had all sorts of stories about what it did and people's relation to it. One of them was that the unicorn could only be caught by a virgin. The only way to catch one was to get a young girl with a nice lunch pack to sit there and sing. And pretty soon the unicorn would come and put his head in her lap, and she could capture it. It is a wonderful image.

Traditionally, the unicorn represented agape. It represented a kind of spiritual love. And it did this for several reasons. First of all, there was supposed to be only one unicorn in existence at any time. So it can stand for the nature of God because the unicorn was unique. Secondly, in the Middle Ages the belief was that its horn could heal anything. So the image of the unicorn as the sacrifice was identified with Christ. It was a one-to-one identification. And the virgin is purity and innocence.

To the right of Temperance *is the painting* Eros, *showing a woman with a lion.*

The lion is our animal nature, and the woman is trying to hold the mouth of the lion. I painted her with clothes because the erotic is very influenced by dress. Clothes have always been an expression

of eroticism, as either a complete repression or a display.

Like agape, eros is one of the aspects of love. But unlike agape, it is self-centered and possessive. You are thinking about yourself and your own satisfaction. Eros is very intense and usually is short-lived.

The great gift of eros is the physical pleasure and spiritual joy it offers. Through sexual desire and union, a person can merge with the infinite.

Yes, the loss of self. And that is our great instigator. One of the great paradoxes of life is that most things we do are to lose ourselves and at the same time to affirm ourselves. Because we are so embedded in ourselves, anything that can take us out of ourselves and yet enable us to return to ourselves is a great thing to be desired.

And the same is true with agape. When a person feels agape, he also feels a loss of self. What agape allows is a love that is not part of your ego, is not a part of your self. It is something larger than that. It manifests itself in everything the person does. None of it is directed toward self-gratification. The person would be charitable in all things. He would want to alleviate the pains of the world anyplace where he could, and sometimes anyplace where he couldn't. But he would try.

What is the danger of taking agape to an extreme?

There is the danger of its easily becoming an affectation, because then it becomes sentimental. It's easy to sit and say, "I love everybody." But it's harder to love even just one person.

More common is taking eros to an extreme. Every individual and every society has to struggle with finding some sort of balance to the power of erotic energy. It generates a lot of enthusiasm and fascination and fear.

Exactly. And it is easy to lose control with the erotic. For most human beings, if erotic energy is separated from love rather than permeating love, it can become a disastrous situation and be destructive instead of helpful. If you let love seem to be only a

EROS

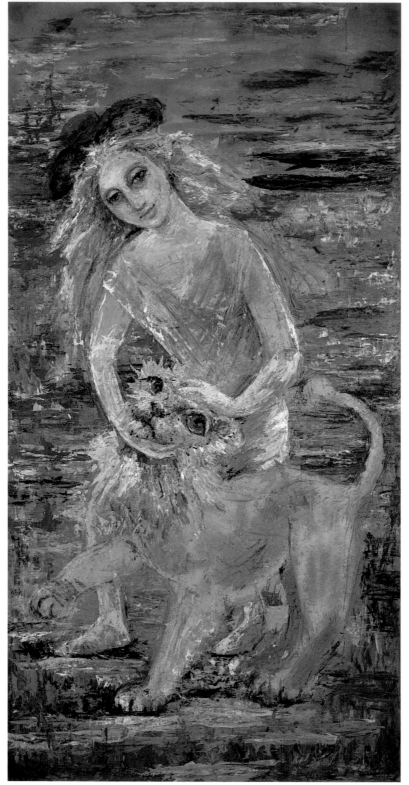

c. 1960
Oil on Masonite
48 x 90 in.

physical thing, like reckless casual sex, it is just a way of avoiding the responsibility that love puts on anybody. Anybody who loves anybody feels a sense of responsibility for the other person.

But that's a hard point to explain to a young person who has little experience and no reference to this idea and has a body raging with hormones.

Yes, you're right. Adolescence is a time of intemperance. And temperance isn't a very exciting idea. When you are young, it looks like a mighty dull way to be, as if all the intensities of life are minimized and maybe actually ignored. But temperance does not mean apathy, where you don't feel strongly about anything. It's a totally different thing. It's the ability to embrace opposites.

So as you mature you begin to see the possible balance in life. Some people never find it at all, and they are just torn from one thing to another all the time.

So temperance involves a few things: being self-reflective, understanding a harmony or order around you, and making adjustments to be in tune with that harmony.

And that's why it's so difficult to make laws of temperance. Because it is really a shifting and moving thing and different for different people. What would be excess for one person would not be excess for another. We are meant to come to terms within ourselves with whatever the thing is, rather than depending on somebody else to find the balance we haven't found.

So real temperance involves balance, but balance within the context of a life that is constantly in flux and developing. That's a paradox.

Yes, it's the core of life and it is very ironic. Balance is a state of rest, but life requires us to change. So if you want to achieve something, you have to dismiss balance and find another balance. But through the power of the imagination you can reconcile that paradox. Temperance enables you to look in two directions and find a way in which something is no longer a devouring thing but is a balanced and beneficial thing.

HOLY POVERTY

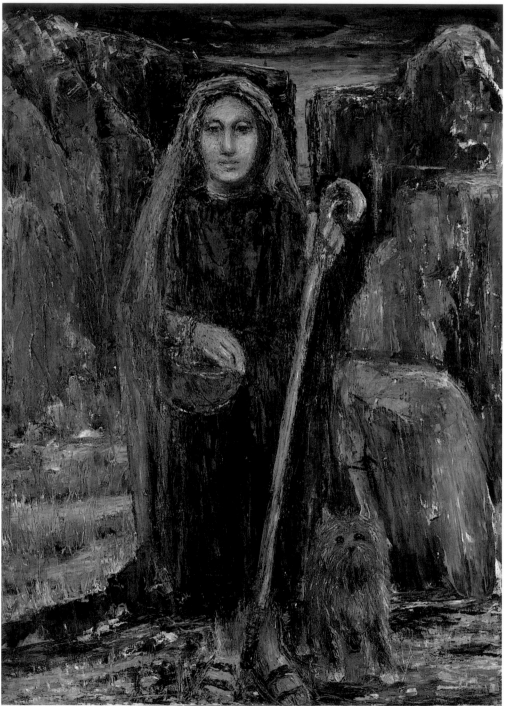

c. 1985
Oil on canvas
36 x 48 in.

Who is the person in the painting?

She's a kind of pilgrim figure, a searching figure. In order to be a pilgrim, you have to reduce your ordinary life to very simple forms, very simple things that don't interfere too much with your journey and what you hope will be the result of your journey. So she has reduced her life to a good stout stick that both acts to help her through a rocky and difficult landscape, which is life itself, and can be used to protect herself. She has some lunch, some food. The only other thing she needs is simple companionship, so she has a dog, which illustrates love. Dogs are extremely loyal and have unquestioning devotion.

What is she searching for?

I think it is a sense of the pilgrimage of life, that you actually need to work toward knowledge of the sacred and the spiritual. She is searching for the essence. It is the idea that the more you abandon, cast off, the more you come to the realization of the actual wonder of living and the mystery of having been given the gift of life. So she wants to live with the absolute minimum by which she can live perfectly happily.

That is the opposite of what is encouraged in our society today.

Our society is all about making us dissatisfied with what we are and do and have, giving us images of what we are not and what we aspire to be.

And that aspiration is essentially impossible. We are surrounded by advertisements that try to create an artificial hunger in us, convincing us we want something that we don't need. So people are in an endless loop of trying to buy and be something they never can be.

I know it. That's absolutely true. We've made comfort so easy and accessible, you just feel like you're crazy if you don't accept it. It's very tempting to think, "If I'm rich, I'll be happy and have everything I want." But rich people are also capable of hating everything about their lives. Rich or poor, the only thing that all people long for is to have something to love. But the terrible thing about money is that people who have it never trust other people's love, because they are always frightened that people might just be loving their money. And there's nothing to do about that.

So with many of the comforts with which we surround ourselves come exponential headaches. We work so hard to attain things that at the end can drive us crazy.

Oh boy, I know it.

But with all the stress of car insurance and all my other bills, I like my stuff, like the car and tape recorder I'm using today. They offer a lot of potential and fascinating experiences. And I'm too accustomed to them. I can't just give them all up. So keeping in mind the lesson of temperance, how do we attain the appreciation for the virtue of holy poverty without going to the extreme of giving up our entire way of life and rejecting everything we own?

The most important thing is to understand and remember the difference between simplification and simplicity. Simplification is a relatively easy, even mechanical, act. It is based on omissions. You can simplify your life by having your telephone and electricity disconnected, refusing invitations and dropping all of your friends. You can never read, never think, and act as little as possible, and hope that the complications of life will disappear. But you will not be a simple person, just simpleminded. Simplicity is not achieved by omission but by integration. It is the uncomplicated organization of complexity. And it is so difficult to achieve that if it does occur, it is usually later in one's life.

So it is perfectly all right to have material possessions, as long as you remember and respect what they are—aids and assistants. In the end, the accumulation of money and comfort can never be a meaning for life. It's a nice ornament of life, but it cannot be the final meaning of life.

So the person in this painting is going on a pilgrimage in search of meaning. It is the sense of sufficiency, the sense that what you are and what you are doing is enough, is the will of God. And its meaning is beyond the material. So she doesn't need a fancy car to get there.

GENTLENESS

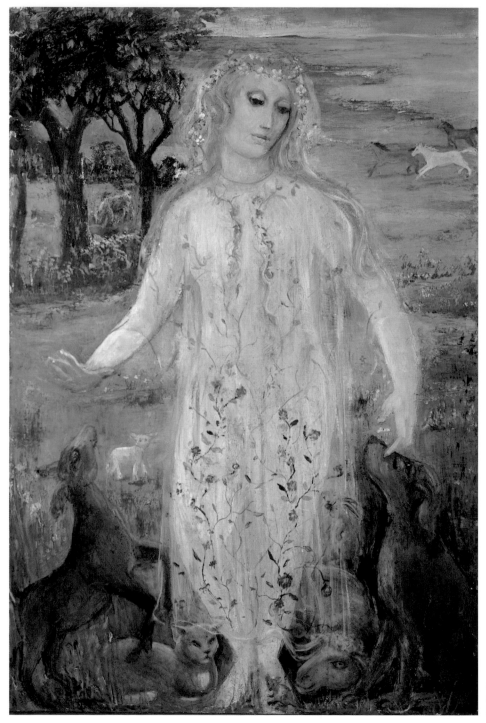

c. 1970
Oil on canvas
36 x 53 in.

I've never thought of gentleness as being a gift.

Well, it is. For one thing, gentleness is always based in love and is an aspect of love. It's always easy to be gentle with the things you love. You don't want to hurt them in any way, or even make them uncomfortable.

And in order to have gentleness you need to have strength. Gentleness without strength is literally powerless. It can be moral strength, with a strong sense of conviction. Or it can be physical, strength that allows a person to stand more and achieve more.

Otherwise, gentleness just seems weak. There's all the difference in the world between weakness and gentleness. They seem to have the same effect, but they are deeply different. No one wants to be weak. Weakness is something that is halfway there or about to go away, not something that is admirable.

Why did you choose to depict gentleness as a woman surrounded by animals?

This painting could also be called *Our Lady of the Animals*. Our relation to animals is one of the great tests of what we are. Animals are relatively powerless, because they are not free when we know them. They are our prey. And their weakness tests the world around them. Will that world protect them, will it ignore them, or will it further harm them? We have to love animals and be gentle with them because cruelty to animals, to any creatures who are vulnerable, leads to every other kind of cruelty. It is a sin against love and against life itself.

That's why I think it's valuable for people to have an animal. It is just an extraordinary experience. Mainly a dog. Dogs are such extraordinary animals. They are so devoted to us and so willing to put up with all of our foolishness and abuse of them and everything else. A dog that has been beaten and kicked around will still love the person who does it. It is an illustration to us about the unconditional love people talk so much about.

In that sense, an animal is naturally capable of achieving a level of love of which most humans are incapable.

Yes, it's very difficult for any human being to achieve unconditional love. It either has to be God or the animals that can do it, because as human beings we always judge other human beings. We can't be as loving and forgiving as a dog or an angel.

Many people who cannot feel or experience love experience the opposite. They develop a barrier or a shell of cynicism.

Yes. There is a coldness and a whole contempt for our human frailty that results in cynicism. The person who is cynical feels separate, as if he has no responsibility to life. He has no sense of the actual connectedness of life, and that is a source of pain.

So the woman who is being gentle with the animals— where does her strength come from?

It comes from love. And the greatest thing we experience as human beings is love—love of God, love of our fellow creatures, love of animals. It comes from the idea that all of life shares experiences—every living thing. Part of what it means to be a living thing is the ability to feel things. A living thing has a sensitivity or a capacity for feeling. And love gives meaning to everything in life. It just does.

JOY

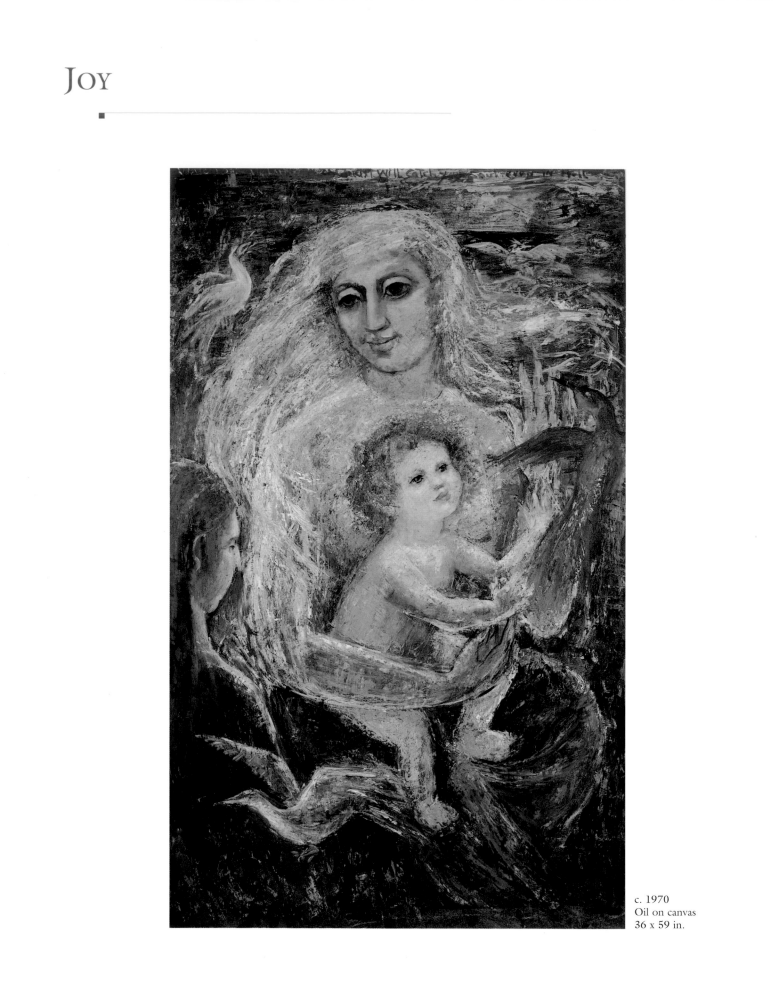

c. 1970
Oil on canvas
36 x 59 in.

If you asked most Americans what is most important in life, they would probably say to be happy. Our Declaration of Independence stands out in part by sanctioning our right to pursue happiness, and we are surrounded by advertisements promising that happiness is right around the corner. Yet many, if not most, people find themselves unhappy and not even sure what happiness would actually be. What is the difference between happiness and joy?

Happiness is a quieter and continuous type of thing. Joy is explosive and totally absorbing. It is an inflow of energy. You can see joy coming into people's faces. It may last two or three minutes but still contain the power to transform the whole person. The mind, body, and spirit all rejoice at the same time.

So you can say, "I'm happy," but it doesn't seem like an extravagant thing. But if you say, "I'm joyful," right away the whole thing changes and you enter another world.

And you can see that in the remarkable connection between joy and love because it happens every time people fall in love. They go around with this goofy look of joy on their faces because it is such joy to find love and experience love. And it doesn't wear off between encounters.

For joy, you painted a child standing on his mother's lap. Why?

Because a child at that age is capable of extraordinary joy. Everything is new, everything is half mysterious, and the world is in the act of forming itself as far as the child is concerned. It is just as true if you have puppies: they frolic and play out of sheer joy. There is no reason for it. It is not an imitation of hunting or something like that. It is just sheer joy.

Children have that, too. You don't have any sense of the limitation of what you are when you are little. You can't because what you are is changing so rapidly that you can't possibly have a sense of limitation. So when you are growing up you have the feeling that you can grow up into anything. When I was little, I was absolutely sure that I was going to be a horse. I though it was just a matter of years, but finally I'd turn into a horse.

But at a certain point in your life, you begin to figure, "This is what I am, and I am stuck with it. It's not going to be any different. I have very little room, and that little room is called 'me,' and there is no getting away from it."

And you see, at that moment you begin to need *a lot* of art. Because art takes you out of yourself, so you begin to feel you are not a prisoner in your own life after all. By making or by experiencing it, art can give you a feeling so powerful that it blurs your self. It gives you the feeling of such union with things that you like and people you like that you just lose the sense of yourself and have this joy of being part of something larger than you are.

So there is joy that a child experiences, which he seems to be born with, which is a kind of purity. Then there is the joy an adult feels when he loses himself through a collaboration or union, like musicians or lovers, or that art provides by connecting people over time and space.

Yes, exactly. Furthermore, you can't command joy, and you can't prevent it. And it's not a touchy-feely thing. It is the opposite. The feeling is so marvelous that it is a kind of ecstasy. In that sense, joy is the ultimate gift of the Holy Spirit. The absolute absorption in joy is an aspect of the mystical experience. The experience is so transcendent that it can actually be terrifying because it can be so overwhelming. Everything that has ever been written about the mystical experience of the presence of God speaks of joy.

Gifts of the Holy Spirit

*I*t's really interesting that all these things we know about and take for granted play such an important role in our lives.

I guess I'm an inveterate teacher, and I want my paintings to teach some things. And I wanted to show that those great old-fashioned things we don't think of as virtues are necessary all through life.

I hope that people would learn to recognize that these are gifts of the spirit and that they would cultivate them and take care of them rather than dismiss them as unimportant. I hope the paintings can help some people recognize something helps them that they can't command, something that is beyond their own individual lives. Because the most important thing to remember is that a gift is given. It is something that you don't control. You are not the determiner of a gift. You are the recipient of it. You are given it, if you will receive it.

So when we say a person is "gifted," we mean that person has a kind of awareness or ability that we consider exceptional.

Yes. A gift manifests itself by a person's having a special sensitivity, and then his actions make it come to life in the external world.

There are many different gifts that people have. I think the great mystery of human beings is the variety of our gifts—the perfectly amazing range of gifts that people have and how the gifts shape their lives and enable them to understand the meaning of their lives. And the gift of one may not even mean anything to the others. Furthermore, whatever gifts we have are not equally distributed.

Some people have the ability to feel depth and meaning in the little tiny things that other people think of as nothing. They can see the whole universe in a pebble or a flower. There are people who have

extraordinary gifts to do things that are absolutely pointless, like engraving the Lord's Prayer on the head of a pin. That's a challenge, God knows, but why?

Some gifts are much rarer and more extraordinary than others. And those people who have them enable other people to have equally strong experiences through them. So a really great painter who paints a still life illuminates that thing for other people who don't have the power to do that but can recognize it when they see it.

If you look around at all the different things people do, there are so many different types of talents that it seems there is an infinite number of gifts.

Yes, I think so. But even though there are an infinite number of gifts that people can receive which come in the form of talents, there is a core set of gifts that are essential to having a valuable and meaningful life, and those are the gifts of the Holy Spirit. If you don't have those gifts, you will always be searching for something. You will always be dissatisfied with what you are and easily made miserable.

So no matter how talented you are, if you are a great artist or scientist or public speaker . . .

If you don't have these core gifts, you have a sense of not being fulfilled in life. You will always feel a sense of emptiness.

I think that the gifts of the Holy Spirit are all accessible. They are not exotic or weird gifts. They may have different degrees of difficulty, but they are all accessible.

So people are born with a gift, and as they mature, there is a point where they have free will. They can choose if they want the gift or if they don't want it.

Yes, that is right.

But if they accept the gift, then it might happen that something is going through them. For example, a gifted guitar player has something going through him, and then it's almost the opposite of free will.

Yes, you are a vehicle.

So on the one hand, you have the free will to decide whether you want the gift. And on the other hand, you are the vehicle when the gift is enacted.

You are just necessary for the gift to be enacted. Your physical existence enables the gift to become part of the world, too, instead of just remaining in the mind or being undiscovered.

So there is a kind of paradox between free will, by which you decide what is happening, and being a vehicle, when something is going through you. But they are both connected to the gift.

That's right. You are consciously allowing this to happen. You see, as human beings we have free will, and we *make* our fates more than we are *given* them. I think we have immense choice. In every single part of life, making or doing anything means making choices. You cannot live a life without making choices.

And though we have control of our lives in this way, there are also times when we allow something to have control of us.

We have proof of this in infant prodigies. You just can't account for a four-year-old child who can play a Beethoven concerto on the piano with a full symphony orchestra. You see, a prodigy is some early expression of knowledge that is way beyond teaching or environment and transcends anyone's realistic expectations of what people are capable of doing. There are only two serious prodigy producers: one is music, and one is mathematics. And it is the greatest example of being a vehicle for a gift. For one thing, prodigies may be prodigious for ten years of their lives and then not any more. They cannot control their gift, and it can be withdrawn at any time. That's the terrible thing all prodigies feel: at any minute every bit of this can be taken away, and nothing can be done about it. Furthermore, everyone can see that they possess this extraordinary gift.

It is indisputable, for example, that this six-year-old child can multiply six numbers by six numbers in his head.

So if the gift is something that is a special talent, why would someone refuse it?

Because a gift is usually a heavy burden on people. Some gifts come at such a heavy price that you want to refuse them. The gift can cause you to lose all the things you love, your wife and your children. It's done it again and again. It can distort life so greatly that it can't be lived with any grace or ease. This is best exemplified by Michelangelo, because he is one of the people who had a perfectly gigantic gift and yet was miserable as a human being. He was totally miserable because nobody could really understand him or know what he was doing. It was very hard for him to make any real emotional connection that was powerful for him.

You see, all things we desire, or to which we aspire, have a dark side. Because creation is the union of opposites, opposites will always come into existence. So even a gift comes with its own difficulties. A gift has social and physical and material aspects to it that work in the world. But it has a dark nature as well as a positive one.

What is the dark side?

It's every sort of negative feeling, really. It is the unconscious and destructive aspect, which is in all of us. It is based in fear and despair—those are the terrible cripplers. It is the feeling that what you're doing is meaningless or worthless. It undermines the faith that you might have in whatever it is you want to do and tries to minimize or suffocate or incapacitate the gift.

So choosing to accept a gift includes accepting a burden that the gift carries. And some people, because of their dark side, would rather refuse the gift and all the beauty it offers because they can't deal with the responsibility that comes with it.

Yes. And people get devoured by their dark side. You see it over and over again with drugs. But there are a lot of things that can be used instead of drugs that do the same thing: Excuses. Anger.

THE DEATH OF THE DRAGON

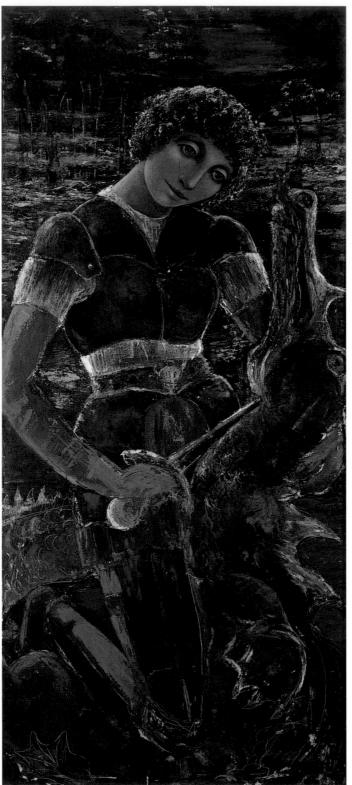

c. 1960
Oil on canvas
32 x 72 in.

THE RESURRECTION OF THE DRAGON

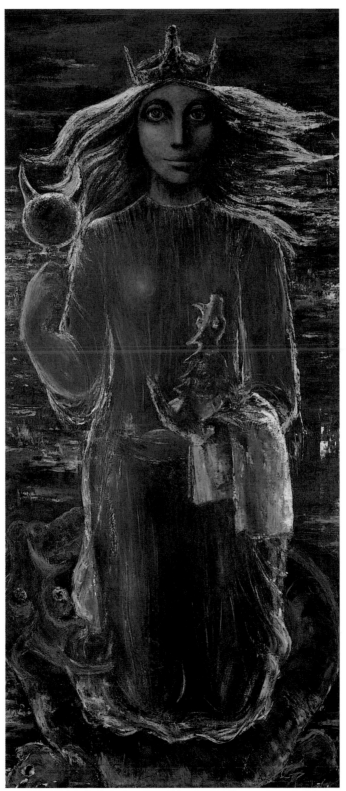

c. 1960
Oil on canvas
32 x 72 in.

Then one must overcome his dark side in order to be fully engaged and take advantage of the gift he was given.

Exactly. And that is why I put two other paintings in the chapel, *The Death of the Dragon* and *The Resurrection of the Dragon*. They are about understanding and accepting and utilizing the dark side of one's nature so as to turn it from a destructive thing to something that is healing and helpful.

The first painting is *The Death of the Dragon*. In the Christian tradition, the dragon stands for the dark aspects of life and the dark aspects of individual people. The young man has just stopped being a boy and is therefore a kind of equivocal figure. He is literally slaying the dragon. It is important to know what is negative about yourself, just as it is to know what is good. Because you cannot change it if you do not acknowledge it first. And the dark aspect must be destroyed for you to free yourself from it.

The second painting is *The Resurrection of the Dragon*, which is the utilization of the dark side and the birth of the whole person. It is a young woman who in one hand is holding a chalice and in the other hand has a baby dragon. The dying dragon is around her, making the *ouroboros* [the serpent feeding on its own tail, an ancient alchemical emblem of the eternal cyclic nature of the universe]. So what she has become is not a person dedicated only to the dragon side but a person who is illuminated and achieves a different orientation toward her whole nature. It constitutes a passage of growth, so the dragon has become fruitful and eminently valuable.

So if you do not destroy your own dragon, it will destroy you.

As it has destroyed many, many people. Or it may just keep you from taking advantage of your gifts, so you will always be in agony. Because an abandoned gift is like something rotting inside of people.

How do people slay the dragon?

Well, that's very difficult to answer. It is just as personal a thing as all the gifts are individual and

unique. But it's a matter of personal spiritual strength that refuses to be defeated by the dragon, when the urge of transcendence over the dark side is so great that it achieves transcendence.

And where does that spiritual strength come from?

That is a mystery to which absolutely nobody knows the answer. It is just one of the great endless and unanswerable mysteries that forever surround us. We are such extraordinary and inexplicable creatures. There is no way to explain what we are doing on this Earth. If you think of the whole vast universe and this little tiny thing that our planet is—it's just a perfectly beautiful blue-and-green dot in the infinite, cold cosmos—it gives you a real sense of the rarity of life. And we come out of nothingness into the world and then disappear into nothingness, leaving no trace of where we've gone. Throughout our short lives we are always in the middle of the mystery of who we are and where we came from.

But we do have the Holy Spirit as a solid connection within all that mystery.

I know it. Thank goodness we have the possibility of the Holy Spirit helping and directing us. We have a friend at court who will stand up for us.

Because the Holy Spirit is really what we call life— the spirit of life itself. It is a level of life that we cannot control and never really understand but is constantly acting on us. And when you are aware of and accept and feel the Holy Spirit, you are simply not in the boundaries of time. It's a very different feeling than just getting a paycheck once a week. With the Holy Spirit, life has more seriousness and more meaning, and it also has a direct effect on your sense of what the universe is about: your life has more depth and height and joy.

THE THRONE OF APHRODITE
THE SAINTS AND MARTYRS OF LOVE

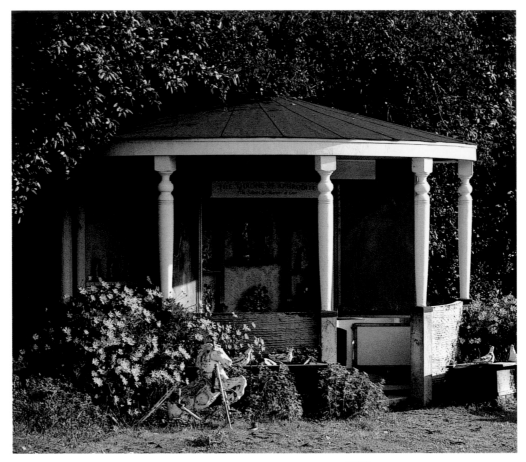

1996
Oil on Masonite and found statuettes
Twelve panels
60 x 60 in. (closed)
60 x 120 in. (open)

Building the Throne

Love

Building the Throne

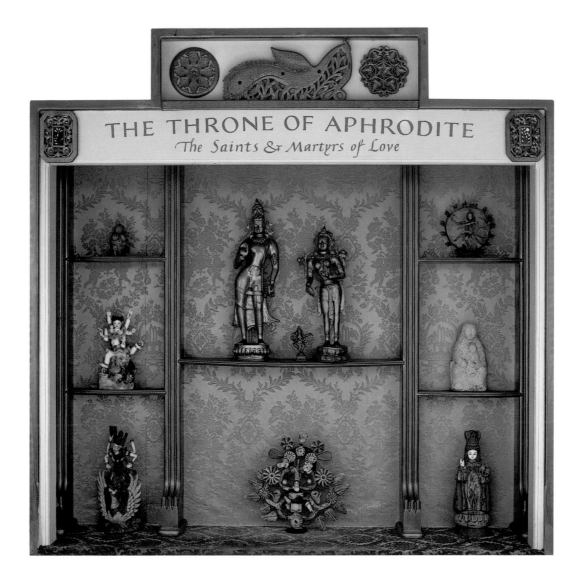

Interior of throne

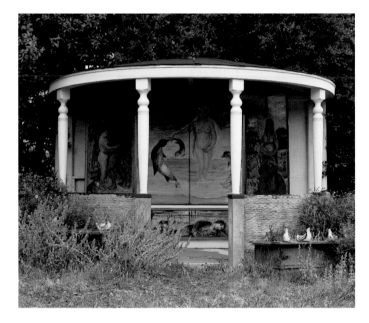

Throne with first layer open

For some time I had wanted to build something to commemorate Aphrodite and all the aspects of love, which is what she represents. Aphrodite is one of the most ancient images or visions of women. So she always carries our history as well as her own. And love itself is probably the most powerful force in all of our lives. Even its absence is a force.

The idea for *The Throne of Aphrodite* came from the *Isenheim Altarpiece* by Mathis Grünewald, in Colmar, Germany. It was made in the early sixteenth century. It is an altarpiece that opens with different layers of doors to reveal more paintings inside. So that the outside has the Crucifixion. But then you open it up, and you see the Resurrection with all the splendor and great beautiful angels.

What I did was take the physical shape of the *Isenheim Altarpiece*. I was fascinated by the way in which you had a very real interaction with the paintings because they would change from one to another. And you would force it to change. You see, one of the things about paintings and drawings is that they don't move, they don't change. And so this was a wonderful way in which they could evolve. I liked that it had a sense of inner life and growth. It was a chance to enrich the experiences of love by binding them all together.

The Throne of Aphrodite is a testament to how some people have been endlessly elevated by love and how some people have been simply destroyed by it. And there is just no end of examples of both things. Of course, anything that is as powerful as love is dangerous. People become martyrs for love because they so passionately care about something that it can bring on their own demise. So I wanted to illustrate this double nature of love—the joy and possible pain and destruction.

JUDITH WITH THE HEAD OF HOLOFERNES

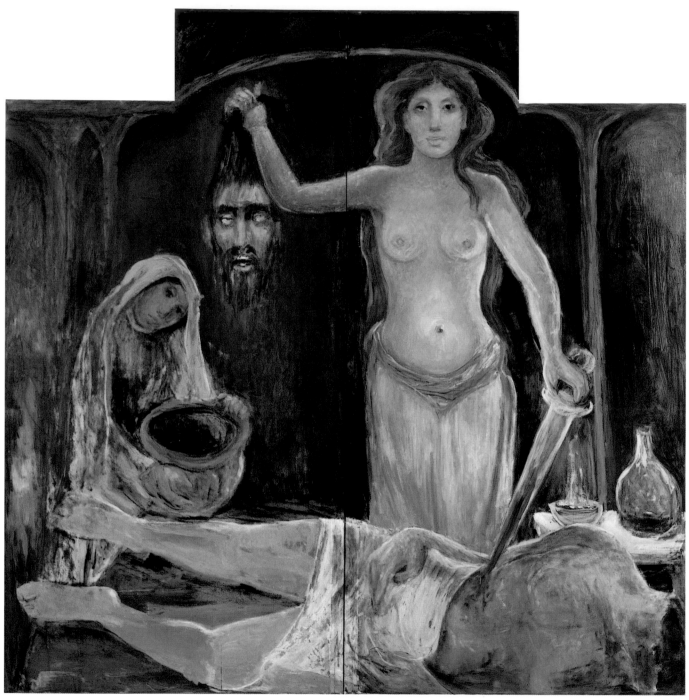

1996
Oil on Masonite
60 x 60 in.

The outside painting is *Judith with the Head of Holofernes.* I am fond of the story, and I have painted it several times.

Judith was a beautiful Israelite widow. The Israelites were being besieged by the Assyrians. So she went out with wine and nice things to eat to give to the opposing general, Holofernes. She arrived with her servant, and she said she wanted to see Holofernes and that she had something nice for him. They searched her, and she had no weapons. So they let her in, and she gave him wine and a nice snack. She was promising him a nice little rendezvous, you see. And then she took his own sword and killed him— chopped off his head and came back out with his head in her hand. They put it up on the walls of the city. And of course his army knew they had lost, so they withdrew.

Judith became a great heroine, and all the people named Judith are named for her. The story is such a great parable of people's sexual lives and how innocently we can walk into a situation that is disastrous for us. Because Holofernes wanted this delightful erotic fun after a long day of battle. But instead he invited his own destruction.

So Judith stands for the false promises of love— where people think, "Well, this doesn't count much, I'll have a little one-night stand with this person." And pow! Either they have some horrible experience or get a disease or, worst of all, they fall in love with the person and can never leave.

THE SANTA CRUZ LOVE STORY

1996
Oil on Masonite
52 x 15 in.

The story, which goes back to 1890, is that this young man fell in love with the daughter of the owner of the local hardware store, and they were very devoted to each other. She died young, in her early twenties, of pneumonia. Shortly after, he killed himself on her grave, holding a bunch of flowers. The love he felt for her was so illuminating that when she was gone it was like darkness and night. Love became the meaning of his life, and when she was gone, life became meaningless to him. He was literally devastated. He could not bear to be without her, and he had to do whatever he could to join her.

So I wanted to commemorate these two young lovers. He is a great martyr of love because through his actions he is showing that love is stronger than death.

HÉLOÏSE AND ABELARD

1996
Oil on Masonite
15 x 60 in. (each panel)

Héloïse and Abelard were the great lovers of the twelfth century. Héloïse was very beautiful and was the niece and ward of a canon of Notre-Dame. She was also highly educated. She was taught both Hebrew and Greek. Abelard was a theologian and the foremost logician and the most distinguished scholar of the time. He was also Héloïse's tutor.

They fell in love with each other, and they had a child together. It became a great scandal and a great love story because it was a time in which love was taken to be the most important emotion people could ever experience. It was thought to be the most sacred and sustaining and important thing possible.

People found out about their illicit love, which was not difficult to find out about, since she had had his child. The uncle of Héloïse castrated Abelard. Abelard became a monk and continued to teach theology. He was literally martyred by love and spent the rest of his life moping around because there was nothing else he could do. And Héloïse became abbess of a convent.

Though they were forced apart, Héloïse and Abelard continued to write letters to each other. She wrote charming, wonderful, delightful letters where she would say, "Nothing means anything to me except your love. Don't talk to me about the love of Christ. The only love I know is my love for you."

So it became one of the great love stories, a tragic love story. But it is not an entirely sad story, because for one thing, the fact that they were separated meant that they wrote these letters, which meant that the whole rest of Western civilization knew about their love. There were other love stories at the time. But Héloïse and Abelard had songs written about them and were just the model of love between a man and a woman that remains despite all difficulties, that stays the most important thing to both of them.

Aphrodite Rising from the Sea

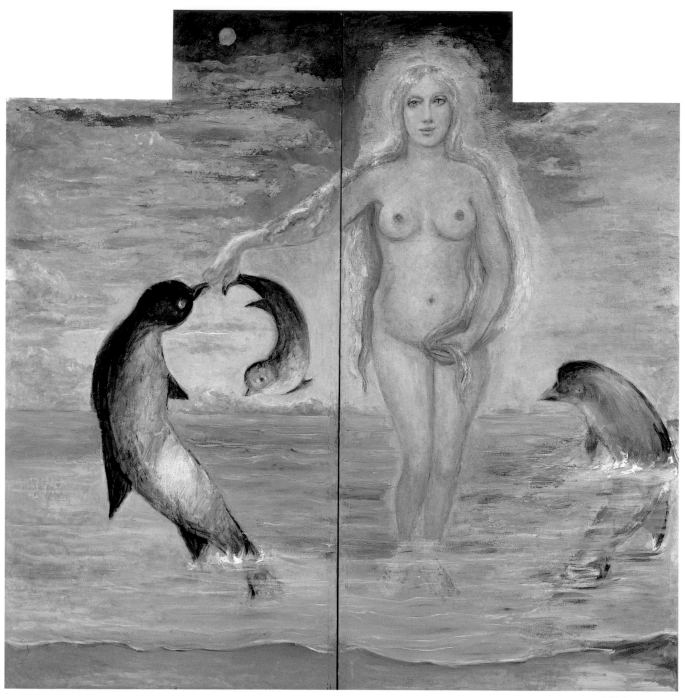

1996
Oil on Masonite
60 x 60 in.

Aphrodite is a fertility goddess but also represents the charms of love. She probably originated in Crete and is known as Aphrodite in Greek and as Venus to the Romans. She is always represented as beautiful. She was born out of the sea foam—the Greek word *aphros* means *foam*—and dolphins are always her animals.

Aphrodite's rising from the sea is a wonderful metaphor because love is so much like the sea. Everything about love is restless and moving and changing, like the sea, not like the ground. And we are equally drawn both to the ocean and to love! Standing by the sea, you just can't believe the endless rolling in of the waves, endlessly the same pattern but never exactly the same pattern. Love is also a very direct and familiar experience, yet it is vast and eternal.

And both are full of all sorts of hidden and dangerous things. If you are not careful, the ocean will just swallow you. Love, too, is such a powerful thing that it has always the power to destroy people, just as it has the power to redeem them and fill them with joy.

ADAM AND EVE

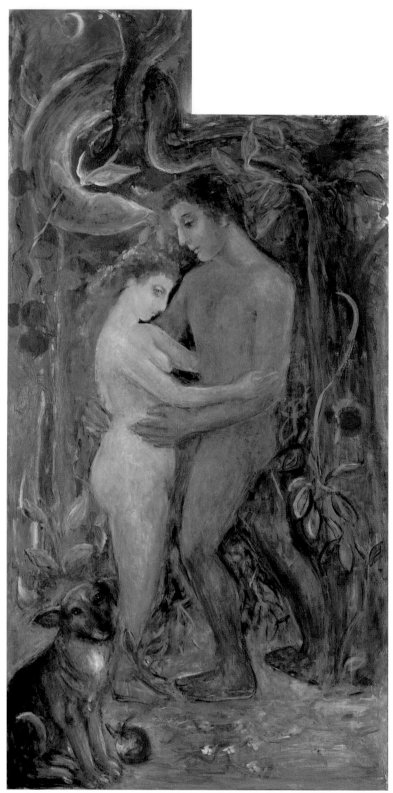

1996
Oil on Masonite
29 x 59 in.

This painting of the temptation of Adam by Eve is completely outside the general iconography of that scene. The story of Adam and Eve is often misunderstood. The old system always was to blame Eve, saying that she caused the fall of man.

I like my version better. It wasn't so much that Eve tempted him with the apple but that they both joined in eating it out of their love for each other. It is so much nicer an interpretation. I also think it's much truer.

The female aspect of God is always love, beauty, attention, care. Women hold the knowledge of good and evil, and they give it to men. Woman is raising man from animal nature, to make him aware he is another species, knowing good and evil. She is responsible for all such knowledge. Men make tools, women make the civilization.

In my little story, Adam and Eve are surrounded by animals. I painted my dog Demi standing next to them. My conviction is that after Adam and Eve ate the apple, they threw its core on the ground, and the dog checked it out, as dogs always do, and ate the core. And so all dogs recognize good and evil. It is how dogs are trained.

I prefer my version—that they are just being delighted by each other and having Adam particularly pleased because he was alone first and had time enough to get tired of that.

And of course Demi thinks they're both pretty funny.

St. Margaret

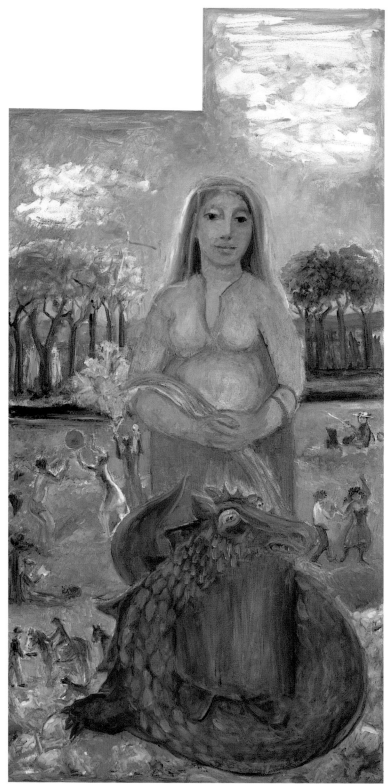

1996
Oil on Masonite
29 x 59 in.

St. Margaret is the patron saint of childbirth, embodying the mysterious future. During the early years of Christianity, about the second or third century, people disapproved of her because she believed in Jesus. So she was put in prison for heresy, and a dragon swallowed her. She spoke the name of God, and the dragon split open and she stepped out whole and safe. She simply parted him like a curtain and stepped out.

In this myth, St. Margaret is enacting a kind of birth. She stands for new life stepping out of the old body—the new, pure, clean, and lovely stepping out of blood, slime, and darkness.

The continuation of life is dependent on childbirth. Pregnant women contain all the mystery of life—of what makes life, what sustains it, and how it will unfold and be understood.

So I thought it was a nice image of love, of the reality of pain and the affirmation of life.

CUPID AND PSYCHE

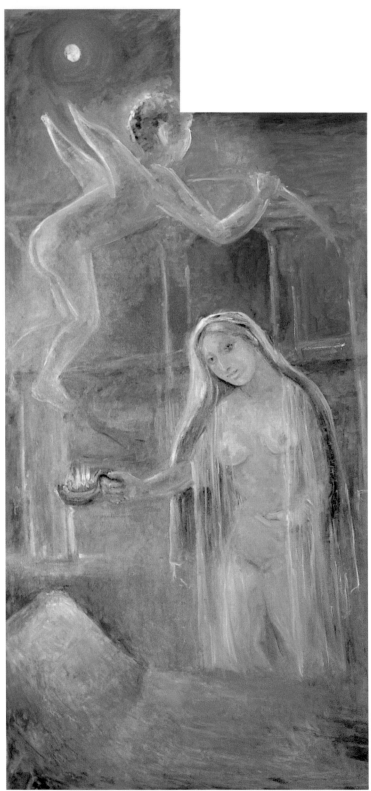

1996
Oil on Masonite
29 x 59 in.

The god Cupid and the mortal Psyche were lovers. But Cupid would come to her at night only. She could never see him, but he was her great lover. So she tricked him and had a lamp ready the next time he came. And when she held the lamp up to see him, she dripped hot oil on him, and he awakened and flew away and never came back.

It makes a very nice allegorical story because Psyche means *soul* in Greek and is the root of the word *psychology*. Humans will examine the soul and the meaning of things, and reality is apt to fly away while we are doing it.

Zeus and Semele were also lovers, and that story, too, is about the dangers of examining love. Zeus visited her in the form of an eagle. She kept saying, "I want to see what you really look like." And he kept saying "No, you don't." And she kept saying, "Yes, I do." Finally she plagued him so that he revealed himself, and she was burnt to a crisp.

It says in the Bible, nobody can see God and live. I think that's been generally true. The intensity of being is so great that it burns like fire.

Psyche and Semele tried to explore love and thought they had the right to question love. But we don't have the right to question love. We just don't have the right. So if you love someone, don't try to figure out why you love them, or what you would have to do to make them not love you, or any of those things. You should be able to accept love.

Zeus and Semele

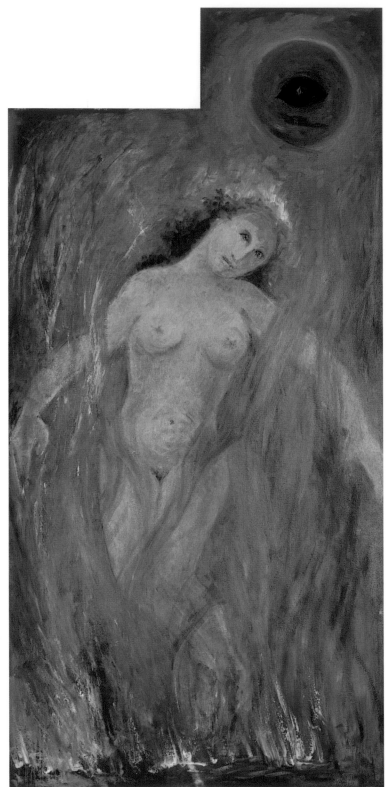

1996
Oil on Masonite
29 x 59 in.

There is the great Greek remark that "the unexamined life is not worth living." The modern variation is that "the over-examined life is not worth living." It can make life too self-conscious. Better just get to the business of living and not examine it too closely.

We want an explanation for everything. And it can be disastrous for people. But lovers cannot resist. They want so much to devour one another. In a sense, you want to eat the one you love. I think the feeling of almost devouring the people we love is very strong because we want them to become a part of ourselves. The fact that they aren't, can't, and never will be is a continuous irritant.

But of course, the story suggests that to pry into another person, as lovers are very apt to do, can kill love. The endless prying Semele was doing—you know, "If you really love me, you'll show me what you look like." They want to know everything about the person, not just whoever he might have loved before, but everything. Particularly people who have just fallen in love, since everything is interesting to you because you're in love.

But the person's other life was lived with other people. And so it can have an alienating effect because the life you make together is the one where your love flourishes. So you should not become preoccupied by the things that don't really matter anymore. To know too much or to be constantly reminded of the love and life that was led before is alienating. Because you're not in it. You're not part of it.

So again, this is one of the ever-present dangers of love.

Love

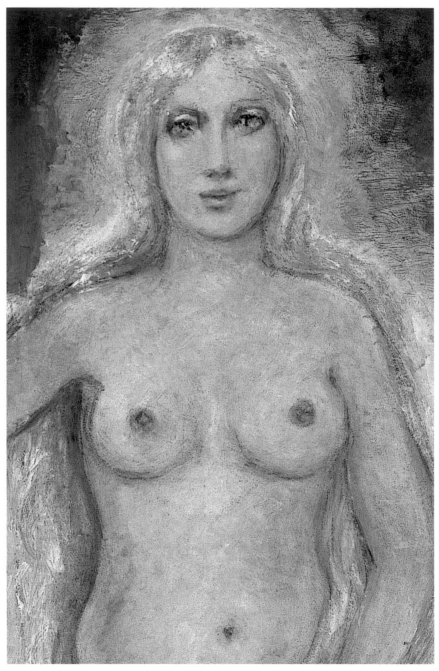

Aphrodite, 1996 (detail)

I have always been fascinated by the strange power of love, and I wanted to build this throne as a testament to its power. And it *is* a power. We essentially don't know what love is. It can take possession of us and we experience what it is, but we don't know what it is. The only thing I do know is that we are meant to act, and we are meant to act through love.

Every single person in the world is obliged to love and to act through love. It really is the thing that we are made for. A loving relationship is the most important thing anybody can ever have. If we don't ever get love or in some way ever find it, its absence means a kind of spiritual death. I think if you are not seized by love, your life is barren and meaningless and sorrowful.

And it doesn't matter what you love, as long as it's a strong and honorable love. You see, love is so complex and moves from a little old lady's deep and strong love for a mangy dog to some poor man who has been blinded by a woman and thinks he can't live without her.

And though we were born to love each other and the world, love can be deceptive and play tricks on people. So people are always getting messed up by the thing. We are victims of love because it is something that seizes us, and there is nothing we can do about it. You have no way to defend yourself, actually, if it is a serious hit.

I remember when I was living in Iowa, my father raised some steers for slaughter. And they always put pigs in with them because the pigs would eat the spilled grains and anything that was in any way edible and helped clean up. So they had a definite function. One time when my father had the steers and the pigs in there, one of the pigs fell desperately in love with one of the steers. Now, this is a love that can go nowhere. And it was not that pigs generally fall in love with cattle—it was just that particular one. She had no way to express herself except by rubbing herself up against his legs or any part of him that she could reach. But the steer is too tall and too big for the pig to have any satisfactory relations. So the steer had no knowledge that he was an object of love, but that did not stop the pig from constantly trying to prove her love.

It was very illuminating, and I was just delighted to observe this relationship. It was a wonderful example of the inappropriateness of love—an extraordinary misfiring of the whole system. Yet it had its uncontrollable power.

It seems to be in the nature of love that you cannot prove anything about love. Generation after generation, people go through the same process of learning about it by living it.

But I believe that the greatest spiritual gift is the ability to love, because in loving we feel both fulfillment and transcendence. It may be pleasant or unpleasant, but you change through love, and it gives meaning to everything in life. And how profound and strong the love is means how powerfully the life is lived.

It is the happiest thing that can happen to a human being, and it is a great blessing from the universe that we can love that way.

INDIVIDUAL PAINTINGS

Mary in her studio with her dog Demi, 1998

FORTUNA

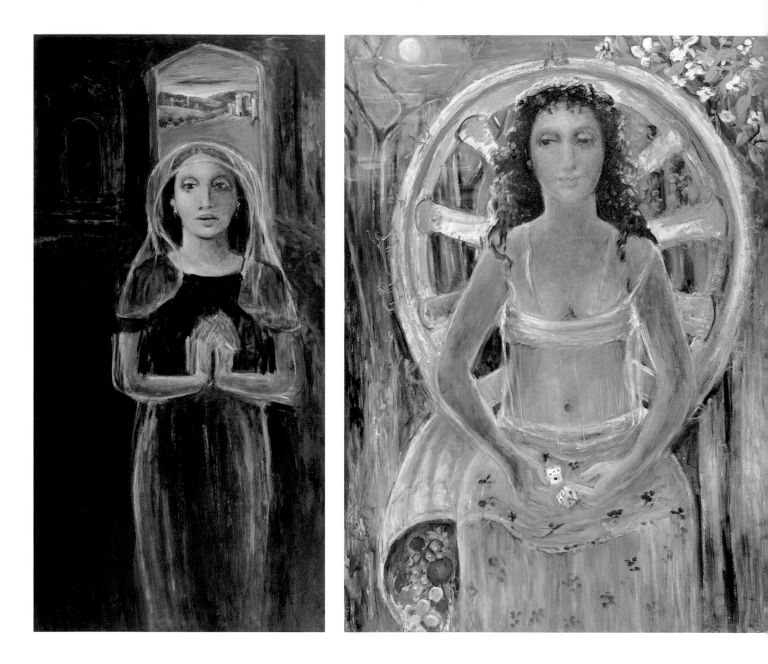

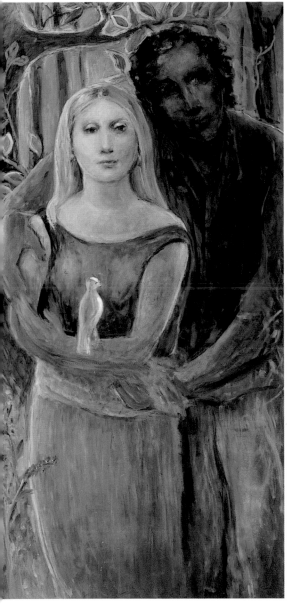

1997
Triptych
Oil on Masonite
83 x 47 in.

This is Fortuna, who has for centuries symbolized fortune—both good and bad. She is the middle figure. She is always represented as a woman. I don't think I've ever seen a representation of fortune as a man. You cannot look her in the eyes because she is too elusive. And she's throwing dice, representing that what happens is due to fortune. It is not due to any of your own prayers or ideas or expectations or anything else. It is simply just how the dice fall.

I particularly thought about the William Blake lines, "Some are born to sweet delight, and some are born to endless night," casting the whole of life into the lap of fortune, really. We are always on the edge of the abyss, and death can touch anything at any time. There is nothing you can do to control it. Some, like the figures on the right, are born to sweet delight and find their lover and experience the blessings of life. And some, like the figure on the left, are born to endless night and are always alone and always suffering.

Behind Fortuna is the Wheel of Fortune. There are people climbing up it and falling off it, which is an image from the Middle Ages illustrating that you can be at the top of the wheel one day and the next day at the bottom, or thrown off into the chaos. We see that all the time in the world. People who have reached some sort of great height can just as easily fall.

Europa and the Bull

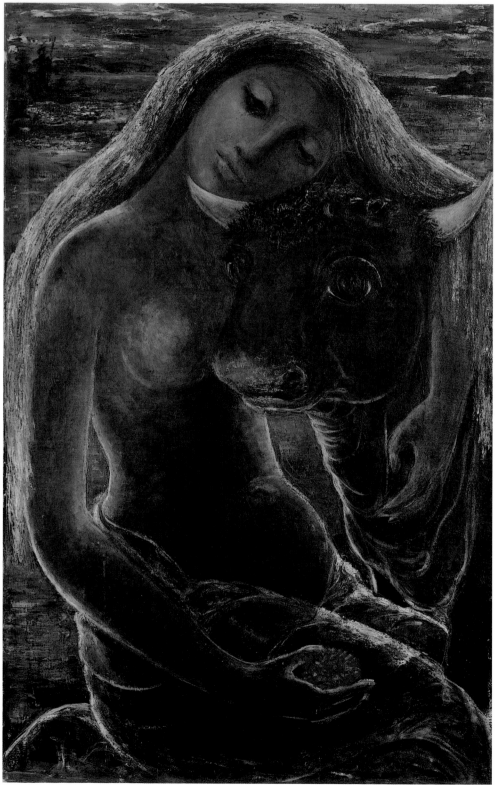

c. 1960
Oil on canvas
32 x 48 in.

c. 1948
Oil on Masonite
30 x 40 in.

Europa and her friends were dancing and picnicking on the Asian shore of the Mediterranean. Zeus saw her and fell in love with her. He took the form of a bull and came and stood nice and sweet around all the people. They were so delighted by him that they made garlands of flowers for him and petted him. Finally, they started to get on him and try to ride. When Europa got on him, he ran to the beach and dashed away across the water and deposited her on the island of Crete. She later gave birth to Minos, the founder of the Minoans, the first European civilization. And that's why Europe is called Europe. (Zeus also deposited the worship of himself as the bull, and of course that still haunts Spain.)

The story symbolizes the radical bringing of the Eastern world into Europe, literally as Europa was carried there by Zeus. In the Mediterranean the bull is always sacred and the bearer of divinity. In the Northern world it is always the female figure that is sacred.

Europa is holding a flower, so that suggests a union of the animal, the human, and nature all in one. It is the wonderful union of those opposites that gave Europe the kind of strength that could pull it up out of nothing to be dominant. It was a cross-fertilization of the Eastern and Western worlds, and once it happened it could never go back. It was written in stone. I think this union of opposites explains the marvelous fertility of Europe, the way it keeps producing extraordinary people and amazing ideas: knowledge of and interest in the historical past, romantic love, science, liberty—all emerged out of the same tiny part of the world over a few hundred years.

Daphne and Apollo

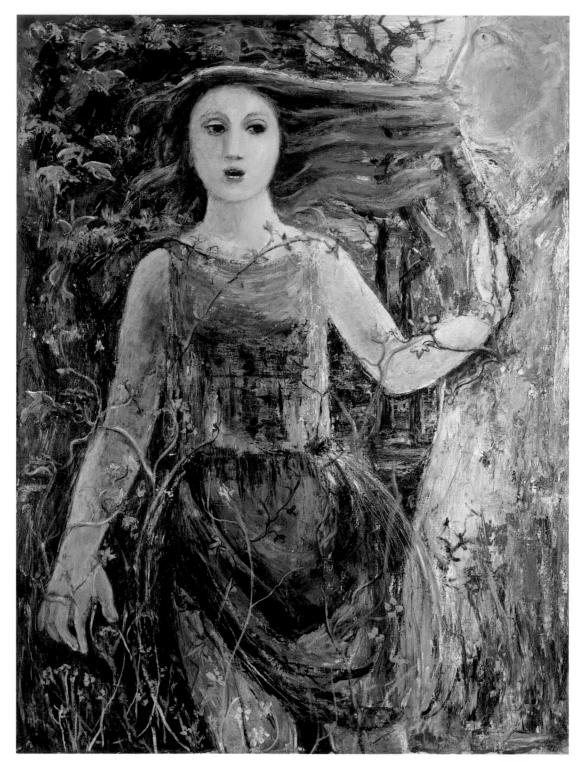

1987
Oil on canvas
36 x 48 in.

Daphne and Apollo is another one of my favorite themes, which is the intrusion of the divine into our world and the havoc that it causes, and how some people in a sense are sacrificed to it.

Daphne was one such person. Apollo, who was the Sun god, fell in love with her, and she refused him because she was afraid of him. She kept trying to run away from him. But of course that is very difficult since Apollo is the Sun. Finally, she ran for protection to her father, who was the river god Peneus. He turned her into a tree, and in that way she escaped Apollo.

In this painting, there is a sense of her hair standing up on the top of her head, which happens when you are in a terrible or peculiar situation. She has one hand pushing away because she is trying to evade or escape, but the hand looks like a tree because she is already becoming the tree. She just literally gave up her own nature to flee the invasion of the divine.

And the result is, I think, a good lesson for us. Because as a tree, what she has done is cut off the enormous possibilities that we have as human beings in order to take safety instead. Because as humans we love the divine but also fear it.

The astonishing power of the presence of God simply seemed to her, and was, a means of destruction. It is so overwhelming that you lose yourself. And of course that is the point, that you should *lose* yourself in the recognition of the divine, in the experience of the divine. But she refused that and clung to what she was. So the paradox of the story is that in order not to lose herself, she had to destroy herself.

JUDITH WITH THE HEAD OF HOLOFERNES

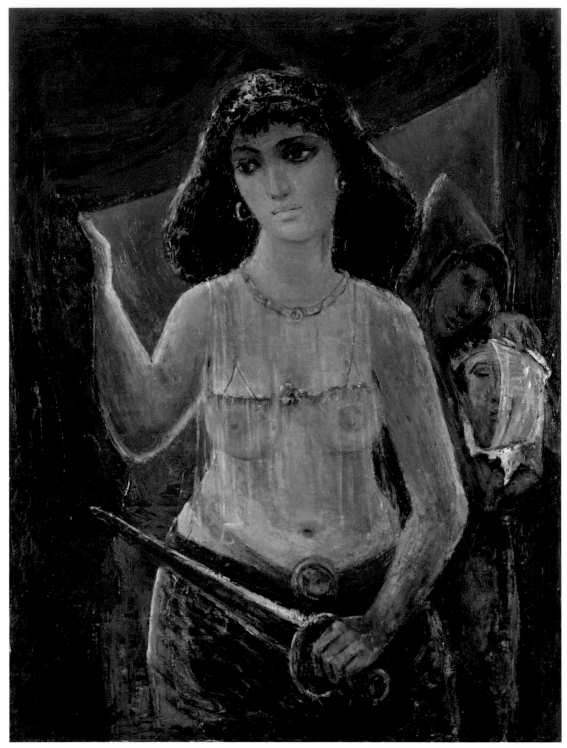

1993
Oil on canvas
37 x 49 in.

THE SANTA CRUZ LOVE STORY

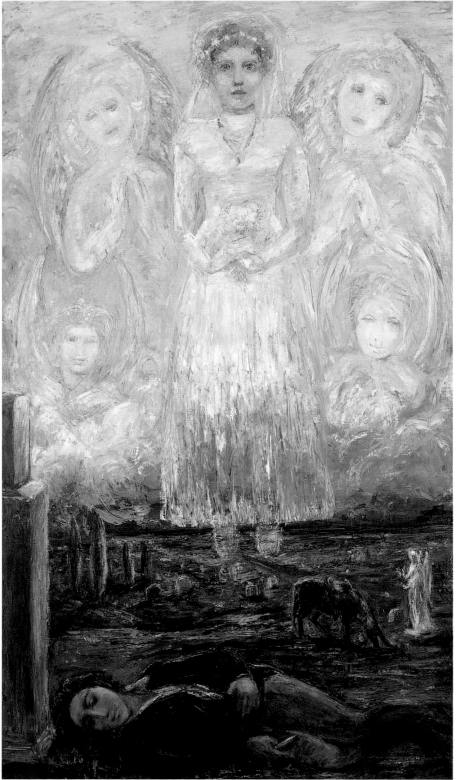

1987
Oil on canvas
42 x 72 in.

THE VIRGIN AND THE UNICORN

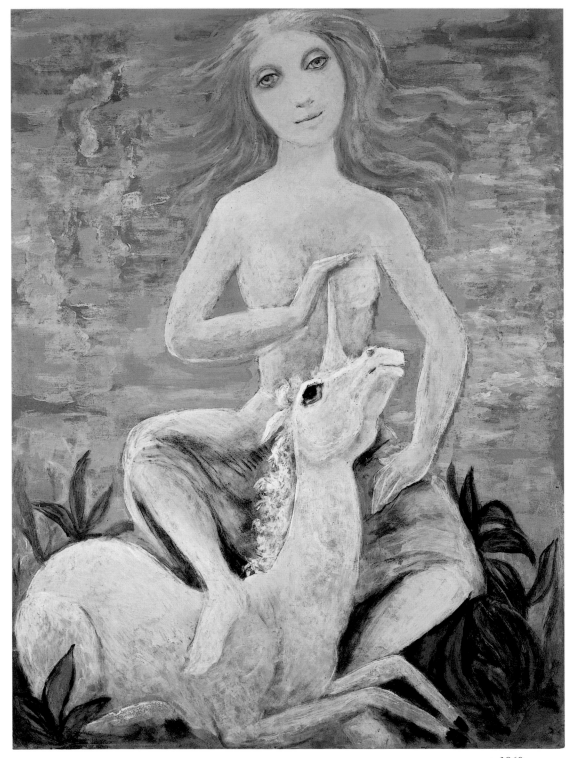

c. 1960
Oil on Masonite
36 x 48 in.

Mary and the Lamb

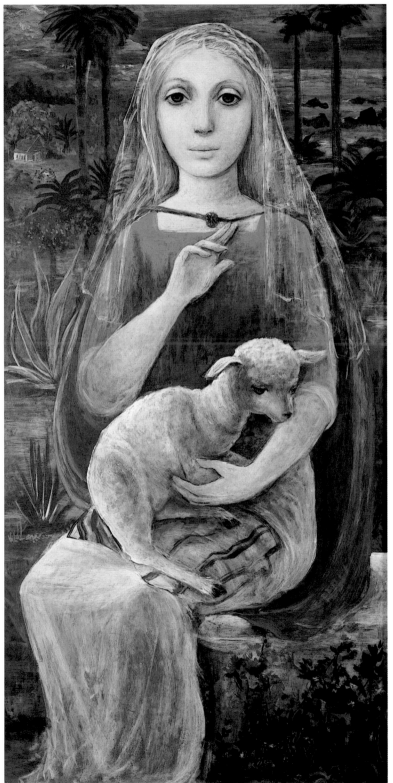

c. 1960
Oil on canvas
24 x 48 in.

MARY'S FARM IN PHOTOGRAPHS

"There are people who have the passion to make something extraordinary, but they don't think that anybody is going to support them because what they want to do is too eccentric, is just beyond the realm of what can be understood or accepted. Yet they feel the inspiration and are determined to follow it."

"Whenever I leave this place, I feel like I'm on a string. I can only go so far for so long, and then I have to come right back."

IDEAS

Art and the Inner Life

"I always say, the whole function of art is to make visible what is invisible. The artist's entire function is for that, because seeing is believing. We long to see the things that we believe but that are invisible."

Since you have been a painter for close to eighty years and an art historian for more than sixty, you have spent a lot of time thinking about and experiencing how art affects people's lives. These days in particular, people are very confused about what art is.

Yes, and you can't blame them. Art critics have written about it in such an obscure way that it's become a great obstacle to people. They feel that they don't know anything about art. In fact, if they have read any art criticism, they are bound to be mystified when they go see the real thing. They don't see where it is.

The only definition that I think is of any use is that art is something made by human beings, as opposed to the natural world.

But most people think of art as something that is in a museum, not something that might be in a garbage can.

If you come upon a hillside in the wilderness, and any inadequate, pitiful person has built a shanty there, you know it was made by people. It doesn't have to be something grand or glorious or even decent. It just bears our mark. Because whatever is made bears the mark of the maker. It is unavoidable. It's just that way.

The great advantage of thinking this way—that art is whatever is made by a human being—is that then you can actually make a judgment on the thing. You don't have to say, "Is it art? I wonder if it's art?" It is art if it is made by a human being. Then the questions are, "Is it any good? Do I like it? Has it any kind of real value?" And if you're waiting to figure out whether the thing is art or not, you can't really answer that.

If you ask the average person, "What is art?" he would mostly likely say art is self-expression, or art is communication, or art is beauty.

When you say that art is expression of feeling and emotion and ideas and so on, you are absolutely right. It *is* the expression of feelings, the expression of emotions, the expression of the self, the expression of the society, the expression of ideas. No question about it. It is that. But so are a lot of other things. In fact, you can't do anything without expressing yourself. Not one thing. The way you brush your teeth is *your* way of brushing your teeth, and it is an expression of your total self. The way you blow your nose, the way you sneeze. Everybody has his own sneeze, and you don't learn it.

But if art were just to reveal the self, if it were just a matter of self-revelation or self-expression, it would have very few followers. Very few. When it is only self-expression, other people don't care for it. You can't ask them to be interested; it's just not interesting enough. Because most people do not make anything that is interesting to anyone except their mothers. It is all essentially refrigerator art. And the fact that many people think of the artist as existing only to express himself has lowered him in society to the status of a child and his work to a plaything.

What about the idea that art communicates ideas and feelings between people?

You will see no end of things written saying art is communication. Art *is* communication; it does communicate. But there are plenty of other ways we communicate with people, too. If you hit someone in the face, that communicates with him very rapidly.

And as far as art being beauty: art is not beauty and beauty is not art. Art may be beautiful, but it doesn't have to be. Too much art is intended not to be beautiful and is not beautiful to permit us to say that art is beauty. Art is not innocently content simply to entertain us with pleasant sensations. If we condemn it to such triviality, we prostitute it.

So art contains self-expression and communication and beauty, no doubt, but it is not correct to say that any of those is the definition of art. They don't go far enough. They don't exclude other things and therefore don't act as any kind of proper definition.

Is there a more specific definition we can give to a work of art?

The only safe definition—and by that I mean the only definition that will protect you in the past and also in the future—all I can come up with—is, "Something made by human beings."

But I have a general reluctance to define things. The language of definitions, like the language of description, is so limited. Just try to describe the taste of milk to someone who has never tasted it, or the taste of a fresh green bell pepper. And especially, things like love or God or reality or art are impossible to define with our rational intellect. In the process of defining, we simplify and distort the thing we are trying to understand.

Yet as people trying to understand our lives, we have no choice but to try to define things.

You're exactly right: we have to try. And though we may never really accurately define them, we can point to and hint things about them.

First of all, experiencing art is what we call an aesthetic experience. The word *aesthetic* comes from the Greek word meaning *to feel*: it is the opposite of an anesthetic. An anesthetic is something that prevents you from feeling. To have an aesthetic experience is to have a response in terms of feeling.

Insofar as we feel, we live. Feeling is the most precious possession of man. By the richness and strength of our feelings we can live happy and meaningful lives even in poverty or illness, or any other adversity.

And the natural and inevitable means of communicating about the life of feeling is through a work of art. Words fail, unless they are poetry. The life of feelings is to be experienced, not described. So you can have an aesthetic experience of anything you see, feeling its beauty or power or complexity or strangeness or an unlimited number of other feelings. And people are constantly aesthetically aware of the whole world. The need to exercise the life of feeling is an absolute necessity to man, as great as the need for food or bodily exercise.

Beyond exercising the life of feeling, we can understand art best by looking at the gifts that are necessary for creating and experiencing a work of art. There are four gifts that are absolutely necessary. They are the power to symbolize, empathy, psychic distance, and judgment.

What do you mean by the power to symbolize?

We are symbol-making creatures. It is one of our great human gifts that we have this unique brain and our type of self-consciousness. It is what separates us from the animal world and is the basis for our ability to make and understand art.

You see, all animals communicate, but they communicate in a very limited way, whereas we have the most complicated kind of communications imaginable: speech, reading, music, dance, drawing. For example, if you draw two dots and a line underneath it, a human being will look at it and say, "That is a smiley face." The different symbols together take on a larger meaning. If an animal looks at it, it just sees two dots and a line. For animals a thing is the thing itself and therefore has all the charm of being that. But they don't have that feeling or need for it to be more or mean something else.

As humans, we live in our minds so much that we are always surrounded by symbols. It is just part of our way of seeing the world, and it makes our lives larger and more interesting and richer.

To make any kind of symbol you need to make judgments—you have to make hundreds of choices. From the very beginning, when a work of art is nothing but in your mind, you are still choosing from what is in your mind. Once it's outside, you are choosing what medium, what material, what size. You cannot make any work of art except on an elaborate system of choices. And choice means that something is accepted and something is rejected.

And there is nothing more important than the

recognition that it is a choice based on values. Nothing can be made except within a system of values. You have to say this is better than that, this is more useful, this is handsomer, et cetera. But to make anything, whether it is a cherry pie or a cathedral, you have to make choices that can only be based on value.

We just move all the time through choice, and because of that, every man-made object is an expression of our total self and a revelation about the person who made it.

How is empathy a part of the process of experiencing art?

It is because of our ability to empathize with things that are abstract that we can, and do, make and enjoy art.

Empathy means losing yourself in something, whatever it is—music, a painting, or another person. In empathy you actually enter the thing. Because if we want to understand anything, we have to understand it from the inside. And the only way we can get to that is by submitting ourselves, sacrificing ourselves to whatever this is, so it isn't ourselves we are looking at but something beyond that. So when you see a person walking down the street with a peculiar hobble, you empathize with him because you know what that feels like. Your body feels it because you are also a human being. You feel what it feels like to walk that way.

So empathy is an ability that is much wider than just art, but it is absolutely essential in art. For anything that we enjoy always means the loss of self. We enjoy through the loss of ourselves—that's the essence. And it's just as true in something completely intimate, like sexual intercourse, as it is in going to the theater.

Everybody, the most ignorant and the most sophisticated, has the same phrase for the enjoyment of anything: "I really lost myself in it," or "I couldn't get into it." If they go to see a play and can't enter into it and don't lose themselves, they don't enjoy themselves. They would never recommend it. If the play can't move you out of yourself, it's not functioning right.

You lose yourself in books. Everybody has lost him- or herself in a book. You can't help doing it. You can lose yourself so much that you are actually inside of the book, and you are totally lost to yourself. You aren't living your life because you are living through the book. You can read a book in which for a minute you are a spider or a cave person or somebody living in the court of Louis the Fourteenth. You are another person entirely. Empathy allows you to be thousands of things that you couldn't be otherwise—for a minute. And when we are those things, we have a better understanding of them.

So empathy is our immediate, spontaneous response to forms and gestures in life and in art. But to complete the totality of our experience with a work of art we also need the opposite of empathy, which is psychic distance.

What is psychic distance?

Psychic distance is the attitude of recognizing that this, whatever it may be, a picture or a play or a piece of music, is not life and is not to be acted on as if it were life.

Art is about life and is embedded in life and reflects life, but it must not be *taken* for life. And the classic example of that is seen when innocent people or children go to the theater. They react as if the play were not art but life. And innocent people do act on that error. Back when there were traveling stock companies in little tiny towns, the people would get so excited that they would try to run up and stop the action of the play. If they saw somebody was about to get killed or hurt or betrayed or whatever, they would run up and say, "You have to look out for him. He's a villain!" And the actors would just have to pretend they didn't hear it.

The irony is that they empathized with the play so much, they got so wrapped up in it, that they got carried away.

Exactly. They didn't have the power to make distance. Therefore the thing is not art but becomes life. So empathy and psychic distance are opposites. But both are necessary, and there has to be the right balance between the two.

So art is not just something that a person makes, but part of the definition is our relationship to it.

The object doesn't change at all. It's what it is. Its potential is there all the time, whether it's treated as art or as life. Way the majority of things that were made in the world that we call art were made out of necessity. People needed these things, whether it was a sword or a costume or a carriage.

But the way of looking at it changes when it's given a separate place, put on a pedestal. You can make an experiment that shows this. It's the easiest thing in the world if you have a pedestal. You crumple up a piece of paper and put it on the pedestal, and then put a crumpled-up paper beside it on the floor. What changes is how we experience it, how we contemplate it, how we treat it essentially. That's what a pedestal does. It brings your attention to any object as something in its own right.

The great example of that is antique furniture at the present time. It was made by somebody who wanted to make the best chair he could and was given a skill to do it. But he didn't think people were ever going to put it on a pedestal and just observe it. And that's what all museums do. They separate the object from what it was intended for or what it was used for and create a space for it where it can be experienced for its own self, predominantly as an object that you are looking at. It's there to be looked at, it's not there to be used.

Art requires distance—psychic distance—because art is an act of appreciation. That is, you separate it from the world. Art requires a space that is dedicated to it. And if it doesn't have that, it doesn't function as art. It functions as something else, whatever else it is trying to do.

So though art is anything made by the hand of man, it has to be separated from everyday life for an audience to pay particular attention to it, or else it just blends in. Psychic distance is what separates a painting from a road sign.

Yes. Because its function is contemplation—you just look at it—not use but contemplation.

You see, the basic paradox of art is that it should be like life and yet unlike life. It should be real yet unreal. Everyone asks this of all the arts, the most untrained person and the mostly highly trained alike. It is their point of agreement, though they may differ in everything else. If it were completely like life, it would be life. If it were completely unreal, it would bore us by its triviality.

It's almost as if the artist has to see what everybody else sees in order to understand the world around him. But he also has this imagination by which he sees things that nobody else sees. So it's as if he has these two worlds going on in his head.

He has to have. Because he can only express one world through the other world. He can only express his imaginary world through the one that is not imaginary. It requires a close attention to the natural world, yet his real intention is the spiritual world.

So let me see if I have this straight: People are capable of making works that are symbolic that can contain all different types of meaning. Each of these symbolic works is formed by making hundreds of judgments and decisions. Then the symbol is something that other people can experience through empathy, in a way becoming one with it. But paradoxically, they are also aware that the symbolic work is something separate and outside life, no matter how much they may be connected to it.

Yes. And the most important thing to remember is that art is meant to be the servant. And if it isn't functioning that way, if it isn't serving people, it becomes shallow. It just can't help it. It becomes really very easy to ignore, as any shallow thing is.

What do you mean by "serving people"?

I always say, the whole function of art is to make visible what is invisible. The artist's entire function is for that, because seeing is believing. We long to see the things that we believe but that are invisible.

So the things that the society wants you to believe, or the things that you yourself want to believe in, you can if you can see them. It doesn't matter if they are angels or microbes. To see them is to believe in them. And the artist allows people to believe something because he allows them to see it.

And so the whole function of the artist has been to do that for people. Artists give people a vision because they have it so strongly themselves. Once the image makes the invisible visible, it is very, very powerful.

Because it allows people's infinite imagination to interact with their finite, day-to-day lives.

Exactly. When you totally enter a work of art, it is the most marvelous thing in the world because it allows you to escape yourself, to lose yourself. And when you do that so totally, you have a great sense of refreshment and renewal.

When people lose themselves in art and then come back to themselves, how do they change? What do they bring back with them?

I think one of the things is a vision of something larger than the self. It is a revelation of reality beyond yourself and everybody. It's just like going on a trip. When you come back, you see everything a little bit differently. Even your most familiar world.

If art offers a good vision, if it is a working one, if it really functions in revealing the essential nature of things, then more and more people share it and it connects people together.

Because as human beings we have in us always a longing for truth. We believe there is such a thing as truth. And we long for it because it is a source of meaning. We have a thirst and a longing for meaning, and we won't live without meaning.

But at the same time, there is absolutely nothing that people can do but confront the fact that we do not know who we are, where we came from, where we are going. We don't know those things, and we have to live with that ignorance. Yet knowledge of those things is the very thing we want. So we are always faced with that paradox. All human beings who have lived, you can be sure, were faced with the same thing. It's a universal human characteristic. The whole of human history has been an effort for us to come to terms with that paradox.

And art has been one of the great ways of doing this. It is one of the things that prompts people to make works of art. Because the ideas that people are thinking about are always invisible. Whether it is a painting of killing a buffalo inside a cave or an image of the Virgin Mary, what they are doing is affirming the reality of this thing. Here it is, because seeing is believing. I think that is the whole key to art, just in that simple phrase—seeing is believing.

Inspiration

*"When you are informed by the Muses, you feel that
you are connected to something that is larger and
stronger and that you have been given something that
you need to do."*

Considering the power that a work of art has to affect both the individual and the entire community, it is interesting to trace a work of art back to the source. That is, art begins when someone feels motivated, inspired, to make something.

It's a curious thing, because nobody on Earth knows where it comes from—the desire to make something. All human beings want to make something. And they are not satisfied unless they do. It might be that they want to make the best pumpkin pie possible. Or it might be huge, like a piece of legislation. But we want to make something and see it—not just to have it in our minds but to bring it into the world.

Some people say it comes from a need for immortality, the desire to make something that will continue to last even when we are gone.

I think that's very much a part of it. We all have a need to continue in some way, so people want to make a mark that will stay and stand even when they are gone. It's a kind of barricade against oblivion. But I think there is more to it than just that, because so often people simply are overcome with the desire to create. And there is no real accounting for it. They just become inspired. Inspiration is one of the most profound feelings a person can ever experience. If you are a painter or writer or musician, there is a moment when it becomes clear to you what you should do. And that moment is the most refreshing. Then you immediately pour out an enormous great production of whatever it may be, pictures or music or whatever. When the story that is your story that you want to tell comes to you, there is no question of any kind of blocking and no difficulty about it. That is a moment of inspiration. Anybody who has ever felt it knows that it is not their own doing, that it comes from outside them and actually goes through them.

The word inspire *means "to blow or breathe into, to infuse," as in something coming in. As opposed to,* expire, *which means "to breathe out or run out."*

What inspiration is exactly has puzzled people forever. So throughout history people have invented versions of the Muses to account for it and to make clear that it came from something else. It is the sense of being inhabited by the Muse, or by inspiration. You are just escorting something into the world, without trying to affect it—as if under guidance, almost as if something is inhabiting you, but it's your own will. And both your will and your inspiration have to be reconciled or accepted as part of it.

Furthermore, the Muse can be summoned, but it cannot be commanded or controlled. It can't be arranged for. It is not anything you can work up to or deserve. It is a pure gift. If the Muses don't come, there is nothing you can do. For many people that is a great anguish, especially writers.

One place that is very easy to observe inspiration and the Muse directly is through improvisation. What I find interesting is that when people are improvising, they are in the moment and open to what you might call a giant "source" of ideas. I once heard it described as "intuition in action." A lot of times, after playing an incredible song, jazz musicians will look at one another and say, "How did that happen?"

Improvisation is a wonderful example of the Muse. In improvisation you can't foresee everything that's going to happen, nor can you control everything that's going to happen. It allows things that you haven't consciously thought of to appear. Sometimes they are silly and pointless, and sometimes they are very deeply insightful. Improvisation allows you to be open to inspiration, so in a sense you just have to follow it. You don't have to create it. Something is

strongly asserting itself. And the very fact that it happens, that it comes into your making and comes out spontaneously and can create something that you would otherwise never imagine, is a great delight and a great mystery.

Another example of inspiration is what I call the Watts Towers Syndrome, named after those marvelous and absolutely pragmatically useless towers in Los Angeles that exist simply because Simon Rodia wanted to see them. He happened to be a mason. He knew how to build in stone and cement, and he wanted them to be there. So he built these extraordinary things that look like some great strange ship moving across the Los Angeles horizon.

There are such people around the world. They are people who have the passion to make something extraordinary, but they don't think—and quite rightly so—that anybody is going to support them in this. They can't even think they can get a grant, because what they want to do is too eccentric, is just beyond the realm of what can be understood or accepted. Yet they feel the inspiration and are determined to follow it.

And the old saying, "Creativity is 10 percent inspiration and 90 percent perspiration" is simply not true. If there's not a better proportion than that, all of the sweat is wasted. It is a bore to everybody and a waste.

Another place where inspiration exists is between people. For instance, a solider can inspire courage in his fellow soldiers. Or a good teacher can inspire students and really change their lives.

Yes, a great many things are inspired by example. One of the places that artists get their inspiration is from other artists. You very rarely find absolutely solitary artists who are not working with or talking to any other artists. It is remarkable what we learn from other people. It is just astounding.

Do you think everyone is capable of inspiration and creativity?

Everyone is capable of making something, and in fact they won't be happy till they do. We are that kind of creature. I believe there has never been a

human being who did not want to make something and make it right, whether it is a pie or a palace. They don't have to make something overwhelming and extravagant, but they want to make a business or an education or collection of something—anything that alters what they were into something new. It is the only way you can comfortably say that we are made in the image of our maker. Because our maker did nothing but make. He made the world, and he made us and everything else. And we sit and try to imitate, sometimes successfully and sometimes not. But nonetheless we try.

But when it becomes a real dominant thing in a person's nature, where he is trying to make something at the height of his own possible idea or level, that is much more difficult and rare. It involves dedication to the craft. The least bit of training allows the artist to make what is really a personal expression. And the lack of that technical skill is a very profound limitation. Without it, the artist is in a prison. He can only move in certain directions. He can only make very small variations, and the personal quality is reduced remarkably.

So in that sense, in making art there has to be a good balance between inspiration and technical skill.

Yes, because people have to have the imagination to see what is invisible, and that is a real strain on most people's imagination. They can't handle it. So the artist in that case is singularly required to have a greater imagination than most people have and greater skill than most people have so he can actually animate his vision and make it come to life.

So there is a paradox in inspiration: there are two opposite things going on. On the one hand, you have to be observing everything, analyzing it, making decisions, executing them with your hand. All those things are control. *But at the same time, you mustn't be totally in control so you can be open to something that is not under your control.*

It is a very delicate balance. You have to be open to the unexpected if you are making anything. But on the other hand, you can't be so open that there is no form or meaning.

It seems to me in many ways that feeling inspiration is

like surfing. You paddle out there, and you are waiting for something larger to come.

Yes, waiting for the wave of inspiration. That's true.

And once you feel it coming, you need to get on and ride. So it is a matter of making minor adjustments to stay on it. But it is also a matter of being sensitive and aware of what is carrying you.

And the person feels it strongly. It is not a mysterious nonphysical thing at all. There is a great sense—you can feel the rush of that type of energy. But not energy as we usually conceive of it, like physical energy or electrical energy. It's a kind of spiritual energy by which somebody's will is awakened or reinforced.

What do you think of inspiration in the context of what is going on in the world of art today?

At the present time art is in a very sorrowful condition in general. The most important thing to realize is that art reflects the society and shapes it—both, and both equally. Most of the ideas of the society come from something that is either religion or philosophy, the interpretation of life in some way. But the artist makes it clear what that means to us inside, clear to our emotional life—what this thing means, whether it is relativity or the belief in fatalism or the vulgarity of the human body or the greatness of the human body. Whatever it may be. The master ideas that guide the society—the artist makes those clear. He makes what is invisible visible to people. This has always been his function, and I don't think there is any question that this is true of all the arts.

I think that the condition of the arts today as a reflection of society is a deplorable thing. Our general worldview—what guides us, what determines our taste and offers us meaning—is for the most part scientific and materialistic and commercial—things that have very little to do with the inner life, the place we live inside of ourselves, our passions and our feelings.

How has that affected the making and the experience of art?

For one thing, everything in our society has become

a commodity. Every single thing: education, the environment, health, religion. There isn't anything you can point to that isn't a commodity and seen that way and treated that way. Everything in the twentieth century about the arts changed because it became a commercial venture. It's handled by galleries and museums and is something that is pushed and promoted.

They tried some years ago to see what chimpanzees would make if they were given tools, paper, and ink to mark with. They gave them a reward if they'd make a painting. But it was not at all successful. The monkeys would just scribble, scribble, scribble, instead of trying to make an actual image of some kind, and then stick their hands out for the reward, the peanut. Their art was corrupted by payment and commerce! It is a great parable of the artist, because if the artist is doing it for the reward, which many of them are, they are just like those monkeys.

Today's artist increasingly doesn't care what he does because what he does is to make something salable, not because he's interested in it or likes it or is trying to say something by it or is inspired. That is all the artist has become. There is no vision beyond the commodity. The artist and the patron agree that making money is the most important thing.

Then also, we live in the most art-saturated culture in the history of the world. Radio, TV, newspapers, and advertisements—everything conspires to flood us with expressions of art. We now live in a continuous feed of impressions and images. So part of the condition of the society, as well as the condition of the arts, is that it is very hard to get anybody's attention.

One of the results, I'm sorry to say, is that the actual aim of a great deal of contemporary art is to shock, simply to get people's attention. Most of the arts have simply become exercises in sensation, and sensation is not at all the same thing as emotion. Whether it is music or painting or poetry, it becomes simply an exercise in sensation. And this is true throughout the whole society.

What is the difference between emotion and sensation?

It's all the difference in the world. Emotion engages

the whole person, and sensation just engages part of him. Emotion is much more complex. It is much more involved. Emotions are the core of people, really the sum of our lives. They are what we believe in and care about. Sensations just deal with the surface. They are just more shallow and strike only one note and don't nearly reach into the person as much.

It is easy to shock people because all you have to do is attack their values, what they consider sacred and important. But to move people emotionally is an entirely different thing and much more difficult. You have to make them literally move from a position of indifference to one of caring.

Art that is meant to be shocking is usually done as a reaction to something in particular, and then it is only interesting to that particular time or place.

That's right, and the last thing a great work of art should display is any kind of provincialism—small-ness of vision or smallness in thought or attitude. In the galleries today, most of the art that is shown is only able to interest people because it's new. And it's kept on being new by your never seeing the thing more than once or twice. I read about a recent art exhibit in New York that consisted of a man running from one side of the room and hitting his head on the wall and running back to the other side and hitting his head on the wall and doing this to the point where he was even more addled than he was in the beginning. And it just made me want to say to this man, "You stupid thing. What do you think you're doing? There is no point to this." We all know that there is an element of absurdity in the world. We don't need to have that illustrated over and over again—particularly at our expense.

So when art has an emphasis on sensation and commerce as opposed to inspiration and emotion, how does that affect the culture in general?

It weakens the whole thing. Because once it is done, it has no shock value and then becomes part of the mainstream. In fact, it's become very hard to shock people anymore. We are so accustomed to expecting some kind of craziness. And it is important to re-member that art shapes people's emotional lives: if their lives are shaped by cheap and tawdry and cruel and stupid things, then their emotional lives will be that.

But artists need to eat also. And though food doesn't give you meaning, love does not give you a full stomach.

Those two things are always battling about which should be uppermost, or which should get the most attention. And no young artist starting out can ignore it if he wants to be a professional.

What would you say to young painters who have to make this decision between personal inspiration and commercial success?

Well, they should make a clear distinction of whether they are going to try to make money and gain attention, on the one hand, or, on the other, try to do something for their own satisfaction or clarification because it means something to them. People have to decide what direction they want to go. Because it's very hard to go in both directions at once.

Many young artists would say, "Sure I want to go with inspiration, but I will be stuck being a waiter for the rest of my life while all these people I know are having shows and people are seeing their work. And my paintings, which are beautiful, nobody sees because they are stacking up in my closet."

I've always said that you need to treat your gift as a vice, that you have to be willing to support it as an addiction. It may be expensive to support. You have to baby it and treat it with extra care. And it has to have a certain priority above other things. Other things in your life will be sacrificed for it, if it comes to that. I really think it is dangerous to rely on a gift to support you. It is not only that as soon as you do that you are making a commercial product. But even then, it is still not something that you can depend on, that you can make a career of. It's very, very rare, like hitting the jackpot in the lottery.

So the process of art's becoming a commodity or a means of generating mere sensation can cause a person to lose his connection to his spiritual inspiration.

Yes. And I think the reward that inspiration can give you is much greater than the frills that the society can offer. Because true inspiration is the greatest

reward that life can give you. When you are informed by the Muses, you feel that you are connected to something that is larger and stronger and that you have been given something that you need to do.

If people limit themselves to what they love or what they believe to be true, then they will be open to inspiration. Because if you believe it to be both true and important, then it liberates you to speak with clarity because you want people to understand it—you do not want any obscurity. And you become passionate about it. If you speak from that love, you are given the power to speak from love itself.

Animals and People

"They are a mirror to us: we see ourselves in animals.
We learn more about ourselves through knowing
something about animals."

In the thirty years you have lived on this land in the Santa Cruz Mountains, you have always had a whole world of animals living with you up here—horses, cows, sheep, goats, chickens, peacocks, and, of course, dogs and cats.

From the absolute earliest infancy, before I could talk, I loved animals. And horses particularly. I have a photograph of myself at about two years old, sitting on a horse with the most ecstatic look on my face. And I remember it perfectly, the absolute joy I felt.

The animals are so fascinating to see. They are so like us and yet so unlike us. Humans have been learning from animals forever.

How so?

They are a mirror to us: we see ourselves in animals. We learn more about ourselves through knowing something about animals.

As human beings, we are part animal, so we are not really divorced from any part of the world. In many ways, we are like vegetables: we need the sunlight and air and water or we die. We have the same basic requirements that a cabbage does. So on a basic biological level, we are all dependent on nature.

But there are things that distinguish the species from each other. Our command of language and use of language is a big distinction. As human beings, we have a far greater range of what we can become than any of the animals.

Before human beings developed the level of technology and culture we have now, humans were much more physically and spiritually connected to animals.

In the Stone Age there was a connection between the human and animal worlds. It was the idea of hunting and killing an animal and worshiping it as a divine source of life. Of course, it was literally true, since people were eating the animals to live. But there was also the feeling that your prey, which supports you, was connected to something larger than either of you, either of your particular lives—connected to life itself. It's something that people feel and have always felt: that there's a kind of uniformity to life, that there is something there which is just life—not life in the form of an animal, life in the form of a person, or life in the form of whatever. Those categories differentiate but do not alienate or separate, really. And through the animal you could connect to that. By wearing the skull of the animal you could partake in the nature of that animal, which becomes a totem animal, a protective animal.

In this way of thinking, that which looks like something, or is owned by something, actually *contains* that something. No matter how small a part you get, that part contains the whole thing. Today, we confirm this with the idea of DNA being in every single cell. But the ancient magical conviction is that if you have hold of something that belongs to another being, that gives you control over that being. Of course, this seems preposterous to modern urban people. They haven't directly experienced that unity and that kinship because they have little contact with the natural world.

And human beings could simply not develop or progress without the help of animals. There have been countless ways that animals have helped humans over thousands of years.

They have always been our servants. They have always worked for us, as they do right now. The use of animals is a way of extending our power, and they have always been valued for that.

People have been modifying and developing behavior patterns for animals all the time. Back when hunting was the only way to get meat, to have dogs was the only way you could really hunt. You had to have dogs to pursue and kill the animal because you couldn't keep up with them. But the dogs could. Dogs have worked for people, and people have selectively bred dogs to get the best dog.

So the difference between having an ox or a mule and not having one would just be incalculable because if you didn't have one, you would have to harness up your wife and children and have them do all the work.

Also, as people developed, they began to learn things from animals that were not simply of the spiritual nature or of physical labor but a kind of combination of the two. The ancient Taoists founded the moves of the martial arts, for example, tai chi chuan, on the study of the movements of animals, whose efficiency they copied in the practice for both health and fighting. To this day, many martial-arts forms, like Praying Mantis Kung Fu, still carry the names of the animals from which they were originally developed.

Well, that's very interesting. It is also the whole idea of Aesop's Fables. They are over two thousand years old, and all of Aesop's Fables are just as true today as they were then. They are stories shown through animals, but what is shown is the truth of human nature.

Like the story of the dog in the manger. The dog can't eat hay, and it doesn't want to eat hay, but it doesn't want the horse to eat it either. So it just keeps snapping at the horse when he is trying to eat the hay. This gives us a category for people. There are a lot of people like that. They don't want it themselves, but they don't want other people to have it.

Animals are a very handy thing to show all aspects of human life. It's not surprising the fables are still around, because they are true.

Well, it's a terrible irony that the human progress animals helped build has now been turned against them. Because as much as humans might love animals, everybody realizes we are in the process of erasing some of them from the planet.

In the nineteenth century one of the most dangerous ideas in the world was developed and seemed to be true to everybody. It was the philosophy of materialism—the idea that the only real things are the physical body and things that can be measured. People's minds were totally captured by the idea that if a thing cannot be counted and measured, it is not real. That philosophy pays no attention to all the areas of life where people really live and where they have their great joy and where they have their pain and sorrow. But because all the things we most highly value and treasure cannot be defined or put into a reliable single state that everybody can understand or read, the materialists pretend all of that doesn't exist.

How did the idea of materialism develop?

There have always been people who said there is nothing but our physical being. Some said it back in Greece, and they convinced a lot of people, then and now. It was popularized in the seventeenth century by René Descartes, who is famous for his statement, "I think, therefore I am." But the main thing he contributed is that there is nothing beyond the physical world. He was hopelessly mired in the idea that there couldn't be anything else because he couldn't measure it.

One of the ideas that resulted from that is that animals do not have any kind of knowledge or love or anything that has to do with the inner life. Descartes himself operated on dogs with no anesthesia. He cut off their legs and tried to see how they would get along. He said, "Animals have no feelings. They only look as if they have feelings." They only make faces, in other words. They don't really feel anything. I hope he rots in hell.

Materialism became the standard philosophy in the nineteenth century. It was an extremely powerful idea because it became the foundation of modern science and then the Industrial Revolution, which has taken over the entire world. It still dominates the minds of almost all scientists. Most of them still believe that anything that cannot be measured has no existence and have no patience with the idea that any other world exists at all. I know that there are some great scientists who don't think that way. But way the majority do think that way.

Even though materialism denies the existence of any spirit, ironically it is still a kind of religious idea because it moved humanity's thinking from "This is how and why God affects us" to "This is how and why we will affect ourselves."

Yes, we have taken over. We are making the world.

We are no longer praying and asking for help. We are actually doing it ourselves. We as human beings think we are more like God than we are like animals.

And even though human beings have done such extraordinary things with technology, our greatest and most valuable knowledge becomes dangerous if it doesn't take into account other living creatures. And materialism is completely against the recognition that every living thing has an emotional life. Because part of what it means to be a living thing is that a living thing is able to feel things, that it has a sensitivity or a capacity for feeling.

The search for knowledge is not an innocent search, and we have developed an absolute worship of knowledge. So there is no guiding principle except knowledge itself. The question of whether this a good thing to do or a bad thing to do doesn't come up for a great many people.

So anything alive, a tree or an animal, will be sacrificed to knowledge.

Exactly. And then it is treated not as a living thing but as an object of knowledge, as an abstraction. And this is very dangerous and disastrous.

It is amazing that as human beings we have gone from worshiping animals to worshiping knowledge, and in a way we are sacrificing animals on the altar of knowledge. Animals have been our friends and servants for all of history and have been an essential element in human development, but the creations of the modern world and the focus on knowledge and science are in the process of destroying the animals. Other than the ones that we keep as companions, the majority of animals are experiencing factory farming, on the one hand, and extinction on the other.

Yes, it is true. We have invented machines to do the work of animals, and at the same time we have started treating animals like machines. Factory farming is, unfortunately, a perfect example of that.

One of the most important things in the world is scale, the size of things: the size of the class in education, the size of the town you live in, the size of your family. It has an enormous effect on how things function. And factory farming functions on an enormous scale. It goes way beyond the human scale, and it's way beyond any animal's scale. So it has to be done by the machine, and that is a very different thing.

It's efficient but impersonal.

Yes. It becomes an extremely different thing from raising animals for slaughter on a farm. The scale of it is simply unimaginable. The animals just become a blur. As opposed to if you are raising ten hogs: you know each one because each one has a different personality. On the scale of factory farming, you couldn't possibly see it.

And if people don't see animals as life that is akin to human life, it is easy to discard them.

I'm convinced that there will be no animals in what is, historically speaking, a very short time. I would say in maybe two hundred years. They will become mythologized and be in museums. Unless there is an enormous disaster or plague that cuts down the number of people.

I thought animals are necessary for the ecosystem in general.

I don't think they are. I know they're not, actually. There are some insects that are necessary because they fertilize the ground. But very few of the animals do that. And because there will be so many people on the planet, there will be no room for animals. They take up too much room, and they simply are breathing too much air and not doing anything for it.

Neither we nor nature has very much sympathy for the thing that has no usefulness. Nature is just as bad as we are about that. So the time of animals may just have passed, exactly as the time of dinosaurs passed. It's a terrible thing, for animals and for people.

The Nature of Paradox and Paradox in Nature

"The more you look at our existence, the more amazing and mysterious the whole thing is. And the mystery of paradox is just an essential part of life."

*I*n many of the conversations we've had, paradox is a recurring theme. The paradox of temperance, the paradox between free will and fate, the paradox of how art affects people ...

Yes. That's because paradox is the natural condition of the world. It is both the working principle and the mystery of life.

What is the nature of paradox?

It is the existence of opposites but opposites that are equal. So that you can say something about one thing, and it's perfectly true, but something that seems to be almost the opposite is also true.

We are always surrounded by paradox because all of creation is the union of opposites. All energy comes from the union of opposites. And it is most obviously seen in the union of men and women. That releases an enormous energy and, of course, new life very often. Because each opposite by itself is sterile. All richness and fertility come from the joining of opposites.

But if paradox is so natural, why is it so difficult for people to understand? You would think that if it is all around us, people would be more accustomed to it and ready for it.

Or at least expect it and not be too confused by it. But I think that when we as human beings encounter something that is deeply mysterious, we shy away from it. We try to explain it by ordinary means, which is of course a total failure. Most people are uncomfortable with paradox. It makes us uneasy. That's because we are physical beings that live in a physical world, and our physical nature is such that we can walk around in different directions, but we can't go two ways at once. That is, you can't go both forward and backward at the same time.

But a paradox combines opposites, so it contains everything.

And if it contains everything, in a sense, it's impossible.

It is an impossibility. It's hard to imagine that something can have that vast a meaning. So a paradox is apt to give people a little trouble for that reason.

A little while back, I felt that I was slowly going crazy from all the contradictions and ironies that I saw around me. So I decided to make a list of all the paradoxes. Would you like to hear them?

How wonderful! Of course!

This first one is obvious because everybody alive on the planet has to deal with it, usually throughout their lives: "You can never really appreciate what you have until you lose it."

Yes, that is one of the things that strikes people late in life, usually—that what they had was remarkable. When you are little, you think that what you are and what you have is natural. You are developing so rapidly, you just don't know any better. You think the life you lead is permanent and that it is going to last forever. So the moment you lose something and it is gone forever, it is suddenly revealed to you that it was really a gift. You realize how precious it was, and that revelation is always late. It can't help but be.

Of course, this happens over and over again to people. You hope it will give you a chance to notice the things that you haven't valued as much as you should have.

This next paradox I've learned the hard way.

My goodness, tell me more.

Honesty is the purest form of the human soul, but lying is the lubricant that makes social life possible.

Both of those things are true. And you are just lucky if you can make a life in which you never have to lie. But it is very, very difficult.

So telling people the truth is the ideal way to live your life, but it is also very dysfunctional.

Honesty is an important virtue. But people have to live a life in which they recognize other people, and other people's desires and interests. They can't just live for themselves. People who are honest all the time are indifferent to other people. Honesty has a double nature: it makes social things possible, but it also makes them impossible. So one of the things that happens with that is that people have a kind of area for honesty and an area for social lying. It's absolutely necessary. Because life needs to have some padding to be tolerable.

So people must pretend to different feelings than their own, just to fit into any social situation practically. Anybody who goes around telling people the truth all the time is not a welcomed guest and never will be. Nobody really wants to hear the truth at a cocktail party.

"How does my dress look?" "Well, the colors clash, and it smells like an old closet."

You can't do that! Particularly if she's spent a good deal of money on it, and it's the first time she's wearing it. It would be very disheartening to say, "It looks like a flour sack on you." So that type of dishonesty is oil for the machinery in a social interchange, and it doesn't do any good to try to fight it.

But it's another inescapable paradox. And if lying is so inescapable, why do we put such a high premium on honesty?

It is self-evident for any group of people that they need to know who they are and how they relate to one another. And that is a function of honesty. As people, we are interdependent, and in order to depend on someone you need to know the truth. If we find someone we can't depend on, we are glad to find that out, so we know to avoid him.

Here's another paradox, unique to our times: the "instant classic."

It's a very funny thing. There is no such thing as an instant classic. First of all, a classic has only gained the right to be called classic because it continues over a long period of time to provide what people want. That is, a classic provides a long-term view and a long exposure into real depth in any particular subject. It is something that requires time to exist—it's got to be given time—to see if it is what it claims to be or what other people claim it to be. But you see, *newness* is the great code word of the twentieth century. Anything that isn't new seems inadequate. All you have to do is look at advertising, because they know what people want to hear. It's the "new, new, new thing." Even though the other thing was perfectly satisfactory, the new one has the trick of being new. And it affects everything: What's new in art? What's new in scholarship? It is a kind of submission to fashion. So then things are not driven by belief or passion or insight but by fashion.

But it's part of this business that we want it all. We want it to be new and instant, yet we want it to be a classic and deep. Very ironic.

This one is definitely a classic: "Women: can't live with 'em, can't live without 'em."

That one is very much a classic, since almost all of history has been recorded by men. Women have always been a mystery to men, just as men are a mystery to women.

One of the great comedies of the relation between men and women is that all men think that women are like children, and all women think that men are like children. Of course, neither of them are like children—they're just like men and women. But in order to get along, both of them have to act as though the other one is a child.

And it's my theory that no men want to get married. Right at the altar they are thinking, "I wonder if I overlooked somebody." And with so many people in the world it's easy to think, "Maybe she's not the one. Maybe there is another woman out there for me."

But then you're going to think the exact same thing when you are at the altar with her.

Exactly. It is one of those great ironics.

This paradox is a real mindblower: We use only three percent of our total brain power, yet our lives are only a blink of the eye in history.

It is one of the ultimate paradoxes and absolute mysteries of what we are doing here.

There is an old Jewish story of man who carries a piece of paper in each of his two pockets. One reads, "The world was created for me." And the other says, "I am nothing but dust and ashes." Each one of us is born with more potential than we can ever fulfill, yet we are such an incredibly tiny speck in the universe.

You can just go look out at the night sky and look into infinity.

It's not like it's something that is hidden from you. It is perfectly clear. This is an enormous universe. People have always had that realization when they have looked up at the sky. The stars have always given people recognition of how tiny we are in the cosmos.

At the same time, we have so much potential inside us. For instance, the power people have that they don't use but can access in an emergency is one of the most amazing things. All people in terrible circumstances have a well of power that they can draw on. It's been illustrated over and over again. Like the woman whose child has been run over by a car who picks the car up and moves it to save her child. Well, in ordinary circumstances she could barely lift the wheel let alone the whole car. And that is a mystery absolutely nobody knows the answer to.

It is amazing how accurately these mysterious paradoxes, which can be so overwhelming and confusing, are represented in the yin-yang symbol. There couldn't be a more perfect drawing to symbolize something that is so hard to understand.

I think it's one of the most beautiful symbols that human beings have ever invented. It has the simplicity that is so difficult to achieve. Very few images ever achieve it. But the yin-yang symbol is self-explanatory—the way the two are bound together. They are alike and yet unalike and form the whole marvelous thing. It's a wonder that a single form can contain so much. What it symbolizes could take volumes. Yet there it is, and it's so clear.

It's also an ancient symbol that carries the exact same meaning to this day.

For one thing, it is very simple. Anybody can make it. It's not like the City of God, a symbol that only a few people can imagine and that even fewer can make a convincing image of. The yin-yang symbol is easy to duplicate. It doesn't require high artistic ability. I'm glad that it seems to be spreading. More people use it or recognize it than did even less than a generation ago.

Probably the healthiest thing a person can do is to grow to appreciate paradox and not fear it. Because then you are not brutalized by obvious confusion, and maybe you can even harness some of its energy.

That's exactly right. If you don't acknowledge the paradox around you, you have to spend so much time defending one position and avoiding other obvious facts that you become humorless. You can become a real dullard that way, because you are cutting off a whole part of the world that you find difficult to explain instead of recognizing it and recognizing that it is difficult to explain.

A lot of people live their lives that way, and it is apt to make their whole experience of life rather barren. In our present time, people think if we can't explain something, it's because we can't *yet* explain it, but we will eventually be able to. But none of the important things can be explained at all, you know. The more you look at our existence, the more amazing and mysterious the whole thing is. And the mystery of paradox is just an essential part of life. It's a source of richness, enjoyment, and wonder. It makes life constantly turn up surprising things for all of us.

The Search for Meaning

"All people need a sense of their place in the world. Not just that there is something that made us but also something to aspire to.... Unless there is some coherent explanation or evaluation of what we are as human beings, we don't know where to go or what to do."

Even though we live our lives surrounded by unknowable mystery, still we are always searching for some sort of understanding. It's as if human beings are smart enough to ask why but not smart enough to answer why.

That's very true. And the classic question is, "Why are we here?" Different people have thought they had answered it, but the answer is not enough for everybody. It's partly because our world is designed—and has apparently always been—so that our aim always exceeds our power to achieve it.

And that keeps us constantly asking. With all our religions and philosophies, none of them can satisfy everybody. So they are constantly being polished up or replaced. But they are never enough, and we are always here with unanswered questions. So there always is that disappointment in ourselves that we aren't whatever it was that we could imagine.

And that is difficult for people, if not intolerable. We want an explanation for everything. That's a very compelling thing for human beings. I do think that human beings are always trying to get at the truth. They may not reach it, but there is a longing that all people have for the true thing. We always have unanswered questions and are left with a continuous longing to know God and to have some experience with God. It's just a plain longing—to know something about his nature. Even people who don't have any religious belief and declare themselves atheists still can't help being haunted by a longing for a connection or explanation for existence. Because we are a kind of creature that *will* find meaning. We will not live in meaninglessness. We just will not.

What does meaning give people?

It is what gives coherence to life and some sense that you understand a little bit of it. The entire meaning

of life characteristically is never totally revealed, but there is a sense that there is meaning, that you can understand part of it.

As human beings we are dedicated to meaning. It is our root material. We have a thirst and a longing for meaning that is so extraordinary and is our great human gift. It is our nature that we can turn everything into meaning for us. We make meaning where there isn't meaning.

One of the greatest examples in my entire life of our willingness to accept meaning happened when I was living in Columbus, Ohio, in the 1950s. I went to see Thurston, who was one of the most famous of the modern magicians. He performed the well-known trick of sawing a woman in half. There was a rectangular box on the stage, and a girl came out in a sort of ballet costume and twirled around and then lay down in the box. Then Thurston cut the box in two. She wiggled her feet before they did this, and she kept on wiggling her feet as they cut the box and even when they separated it. Then they put the two boxes together again, and she sprung out of the box and twirled around as happy as you please, bowing and proving that she was together in one piece.

After the show, as we were leaving the theater, I was walking behind two women who were talking about the show and saying how much they had enjoyed it. The ladies, who were in late middle-life, neither senile nor too innocent, were speculating how he had cut the woman in two. One of them said, "I don't see how he cut that woman in two." And finally the other said, "She was paralyzed from the waist down." "That must have been it," said the first. And she was perfectly satisfied by the answer. Well, of all the unsatisfactory explanations! If she was paralyzed from the waist down, how did she get unparalyzed and go jumping around the stage?!

But they were perfectly content. It seemed to them

the right explanation, even though the explanation was so much more mysterious than the event.

But the interesting thing is that they needed to know.

They needed to know. Though they had gone deliberately to a place where a magician was intending to fool them, they had to have an explanation. It always struck me as one of the great examples of our furious insistence on meaning and the wonderful agility with which human beings discover meaning. We have an extraordinary ability to encompass things that we don't understand and feel that they are quite easily understood.

So the meaning can be inaccurate but still sufficient.

Any explanation will do as long as it poses as an acceptable explanation. It doesn't need to have anything to do with reality as long as it has the power to affect people and make them believe it. We have this marvelous ability to make excuses and to explain things falsely. We won't live without meaning, but we are satisfied with very dubious meanings. And there have been a thousand million meanings that have been adequate for people, sometimes developing into whole complex religions.

In that sense, ancient religions and modern science have in common that search for meaning. Every culture in the world has a creation myth because everybody has wondered, "How did we get here?" And no one has the *answer, but everyone has a version.*

All people need a sense of their place in the world. Not just that there is something that made us but also something to aspire to. Meaning motivates us into being able to do all types of things. Unless there is some coherent explanation or evaluation of what we are as human beings, we don't know where to go or what to do.

So meaning gives both comfort and direction.

That's exactly what it does. Those are the two things people want all the time. Because it's not enough just to know where we came from. We still need to know what to do next.

And everything that offers meaning and tries to

show people how to live, whether it's a religion or a psychological theory, the idea of living fully in pure real consciousness—that is almost everybody's ideal. The more fully conscious you are of what's around you and what you know and see, the richer your life and experiences will be.

And what if people don't have meaning, or lose it?

If people do not have a satisfactory meaning in their lives, then they try to entertain themselves. That is why so much of this society is simply dedicated to entertainment. That's why there is such a huge entertainment industry. It never had any such proportions before. You just have to remember that in the decline of Rome they started to use real gladiators instead of actors. The people who give us the entertainment are by far the most exalted people in the society, and I think the best paid.

But if the lack of meaning becomes acute, it produces despair. It is devastating because it undercuts everything people do, no matter what it is. Because the second people lose a sense of the meaning of life, they are seriously ill. If you reach total meaninglessness, that is just clinical depression. The mental hospitals are full of people who feel that life is meaningless and cannot do anything but sit and grieve. They can't see any reason for getting out of bed and getting up in the morning. And people who feel that life is meaningless will try to kill themselves. Either instantly, by suicide, or slowly, with drugs or recklessness or any other way. You cannot lead a meaningless life without extreme pain and illness.

We definitely live in the age of the midlife crisis.

Except now, it is the whole-life crisis. You could talk about it endlessly because it is one of the great inadequacies of our time. All the meanings are fractured. They are split so that there is nothing that we as a civilization can agree upon that is sacred.

In the past, meanings were clear to all people. All societies in any previous time simply provided the basic meanings that people need: Why are they here? How did they get here? And once here, how should they act? That used to be the great function of religion. Religion is the gathering together of

meaning, in the sense that it applies to everyone. It gave life point and purpose and told people how to act in order to achieve that meaning.

And in the past, when people lived in small communities their entire lives, it didn't occur to them that there were different ideas about meaning outside their society.

They didn't have any need for it because they had plenty of meaning inside. But those meanings change through all kinds of things. As the world progressed with technology and became more global and interconnected, different meanings came in contact with one another and were put to the test. Meanings that were perfectly satisfactory because they were in little sections came into a reality check that was very hard on them and could undermine them completely.

Take, for example, the invention of the microscope: what an extraordinary thing! You see what you couldn't possibly see without it, so you create another world. Although that world was unimaginable before, it's perfectly accessible to anybody who looks though a microscope.

So when we learn that other worlds exist, we need to come up with a new meaning.

Yes, a new meaning that includes that new world and that new potential.

We now live in a time that is marked by so much new potential. Science is constantly inventing and reshaping the way we live. If you go to a library or museum, you see more information about different cultures and their ideas than you could possibly digest in one lifetime. For all that potential we need new meanings to explain things.

And that is the real agony of the time we are living in. What people suffer from now is that there are too many meanings. We have so many answers that none takes precedence. They don't have the strength that is needed. And there isn't one rule about anything that applies to everyone. There isn't one meaning that ties all people together.

It is the character of modern times that people have

to find their own meaning. Because if the society doesn't offer an explanation that is satisfying to most people, then people have to work out their own separate little meanings. And that's a terrible requirement because most people really are not equipped for it. And they've never been asked to do it before. It's not in any way easy, and most people fail.

But we have a sense in this society that we can create ourselves, that we can make something out of what we are that other people will recognize. We think that meanings should be discovered by the individual, that it is not the obligation of society.

How do people find meaning in their lives?

People get meaning from their experiences. Love, work, and suffering are all experiences that can give meaning. None of them *has* to, but they can—they have the potential. Those three things tie you to something outside the self. Love, work, and suffering challenge you to relate to the larger world or to other people or something that has a greater purpose.

Also, tradition and ritual offer a strong sense of meaning. Everyone aspires to be connected with something that is larger than themselves, longer than their own short lifetime. Something that is just plain bigger. Whether it is a harvest festival in an ancient society or the football season in our present culture, these things, with their ritualistic qualities, are a refuge for the individual. They feel protected by the larger thing.

But most people are very limited in their inventions. So a lot of people find meaning by becoming obsessed. It is why people develop vices, because a vice gives meaning to the world. For a person addicted to drugs, nothing else matters. Everything falls into place, like filings on a piece of paper when you put a magnet under it. Life all of a sudden has urgency and purpose and focus. So a carnal fixation gives you meaning. But it is a very easy way to get meaning, because the person is investing sensation with meaning. But finding meaning in mere sensation is a shallow meaning because it results in just being locked into the self, and that doesn't sustain you.

So there are two directions a person can go in to find meaning: a false way or a way that is thorough and complete.

They are types of concentration, that's all. But it makes all the difference in the world which one you choose. It can absolutely become pathological, or it can be an assistance to the way you live. One just leads to death and despair, and the other one leads to meaning and life.

You said that societies used to provide meaning for people. What about a meaning that will connect people as one group now?

That is very difficult. We are living right now in a time of immense longing and desire for some kind of revelation that would give us a new hold on life, give us a new sense of the meaning of the world and what we do. In fact, I think we are overdue for a revelation.

But you know, you can't demand that there will be revelation. You can demand all you want, but you won't necessarily get it. We are absolutely dependent on whatever it is that is running the universe. And our major giver of meanings is something that we cannot control. That kind of revelation is given at different times and for different peoples. The only thing that can get us back on track is somebody's very powerful vision, which will be contagious. And everybody will succumb to it and see it as true.

Like a prophet?

There are path-givers, the people who have a profound vision of the meaning of life and make a path for the rest of us. They are few and far between, but they appear at times of difficulty. Because we have access to a lot of history, we can see it happening when a new religion is introduced.

The Buddha realigned people's thoughts about what the meaning of life is and what you should do about it. It shifted from one position to a totally new position. The great thing Buddha did was to say that all we are obliged to do is to lead a decent life, imposing on people as little as we can because we are all in the same boat.

Christ did the most extraordinary and the most unbelievable thing: he believed in and taught that we should love each other. And this is such a fantastic idea that nobody ever had. Almost every religion before that had a whole list of rules of what you should do and not do. But this was different because it required an internal change and made love the central meaning of people's lives. He transformed the relationships between people by saying you are supposed to love your enemies, though we all know it is difficult enough to love your friends. It makes it seem that it is a possibility, that it can be done.

In the twentieth century, Albert Einstein functioned the same way as prophets always have. Because today science acts exactly as religion acted in previous societies: it aims to explain everything that goes on in life. He gave people a new way to interpret and understand the universe. And everyone turned to Einstein as a prophet when he was living. He was asked to comment on anything that occurred. I remember that when women began to wear skirts that were above the knees, the newspapers would have Einstein's comments on the new short skirts, as though he were a fountain of wisdom and not just a scientist who had a theory about the nature of the universe.

Is there someone acting as that prophet today?

I don't think so. I don't think there is anyone who has captured people's attention with a new meaning of how we should live.

It seems like a very difficult time for a person to offer a new meaning. So many people believe that life is meaningless, and many other people believe that their religion already gives them the answers so that they are not interested in listening to any new ideas.

The power of whatever idea or series of ideas motivates a society is not easy to change. Even things that seem quite absurd can be believed for a long time and followed and acted on.

The appearance of a new vision of meaning doesn't mean that the entire world shares it, necessarily. It means that enough of the world does, that it becomes significant to a large number of people.

That has always been true. Whenever there is a new prophet or a new visionary, there are always resisting groups. And some of those groups resist forever. They are affected by it by contrast, but they are not necessarily converted to it.

So what do you think this new meaning will be?

If I knew, I would be the one who would make the announcement!

Well, what we do know is that meaning is the question. It is what people seek in religion, science, philosophy, history, and art—all in an attempt to understand and explain why we are here and what the point of it all is.

That's right. We are born without any clear meanings, so we make them clear to ourselves.

But in a world that is always changing, it doesn't seem possible for people ever to understand an ultimate meaning for all people for all time. So human beings will always be searching for meaning. In that sense, is it fair to say that possibly the meaning of life is the process of searching for the meaning of life?

I think it is. I would say that it is the point of life.

The whole amazing cosmos has always been conspicuous to people. Anybody who has a set of eyes can see the stars and see the changing of the Sun and the Moon. We see that the universe is working, and we cannot help thinking about the extraordinariness of our position in the cosmos. And we have imagination and speculative ability, so we always wonder about the mystery of our lives. We want an explanation of the whole world. It is just part of being a human being.

So people have spent their entire lives trying to find a satisfactory answer to why we are here. In our short lives, we are given a certain amount of time to search for it and find it. Some people find satisfactory answers, and some people don't.

I think that the people who find the most satisfying meaning in life are the people who have a purpose. That is the most important meaning that life can have—that you have a purpose and that you have a possibility of fulfilling it. The most dreadful thing is never to find any real purpose in life. It is a real tragedy. People who do not have a sufficient meaning feel constant pain from not being attached to something, and they will always try to lose themselves with distraction to avoid that pain.

But those who have meaning will actually find themselves. They have more of an understanding of how they fit into the world, and as a result they can deal with any pain because of the meaning. The person who has meaning and purpose has more strength, more clarity, and more of a sense of his own being and his relation to the universe.

With balloon hat, 1996

MARY HOLMES
PAINTINGS AND IDEAS

Addi Somekh: Interviews and Logistics
Charlie Eckert: Photography and Improvised Carpentry
Gideon Rappaport: Editing and Quality Control
Bruce Cantz: Oral History and Organic Kosher Wine

We are deeply grateful to the following people for helping bring this book to life: Becky and Michael O'Malley and family, Eta and Sass Somekh, Larry Makjavich, Andrew Wermuth, Phil Freshman, and April Doby.

Thanks go as well to the following, for contributions of all kinds: Betsy Buchalter Adler, Brad Alerich, Dr. Michael Alexander, Greg Apadaca, Katherine Beires, Jim Bierman, Jim Borrelli, Angie Christmann, Cowell College (UCSC), Demi, Anne Easley, Stephanie Elkin, Barbara and Charles Embree, Crissie Ferrara, Dan Gunning, Jim Hair, Hannah, Alicia Hernandez, Hi-Rise Bakery for the best sandwiches in Cambridge, Betty Hotchberg, Tracy Hunter, Jan and Jerry James, Coeleen Kiebert, Paul Lee, Anita McCreery, the research librarians at Dean McHenry Library (UCSC), the Meck family, Dr. Nanette Mickiewicz, Helen Miljakovich, Elizabeth Murray, Jennifer Ortega, everybody at the Penny University, Jill Pinney, Mary Quillin, Kelsey Ramage and Bookshop Santa Cruz, Doreen Schack and the UCSC Alumni Association, Christian and Joel Smith, Talli Somekh, David Stanford, Lucinda Swan, Rosalind and Bob Thomas, Beatrice Thompson, Peggy Townsend, and Bill Tracey.

Finally, special thanks are due to all the people who subscribed to buy this book when it was just a concept, making the initial printing possible. It would not have been published without their help.

First Edition

Published by
Very Press
P.O. Box 3091
Los Altos, California 94024
verypress.com

Designer: Andrew Wermuth, Cambridge, Massachusetts
Manuscript editor: Phil Freshman, St. Louis Park, Minnesota
Printed in China by Palace Press International

Cataloging-in-Publication Data

Somekh, Addi
　　　Mary Holmes: paintings and ideas / introductory
　　　contributions by Addi Somekh and Gideon Rappaport;
　　　interviews by Addi Somekh; photography by Charlie
　　　Eckert. —1st ed.
　　　p. cm.
　　　ISBN 0-9708298-1-7

1. Holmes, Mary, 1910–2002. 2. Painters—United States—Biography.
3. Holmes, Mary, 1910–2002—Criticism and interpretation.
I. Rappaport, Gideon. II. Eckert, Charlie. III. Title.

ND237.H6696S66 2002　　　　　　　759.13
　　　　　　　　　　　　　　　　　QB133-539

Documentary photography credits:
Facing title page, UCSC Photo Services, 1978; p. 10 and back cover (bottom), Helen Miljakovich; p. 12 (top and bottom), Collection of Mary Holmes; p. 13 (top and bottom), Collection of Mary Holmes; p. 14 (top), Vester Dick; p. 14 (bottom), Collection of Mary Holmes; p. 15, Betsy Buchalter Adler; p. 16 (top), Jim Hair; p. 16 (bottom), Collection of Mary Holmes; p. 17, Aletha Biedermann; p. 72, Michael O'Malley; p. 126, Charlie Eckert.